SURBITON
THROUGH TIME
Tim Everson

AMBERLEY

For Charlie.

First published 2017

Amberley Publishing
The Hill, Stroud, Gloucestershire, GL5 4EP
www.amberley-books.com

Copyright © Tim Everson, 2017

The right of Tim Everson to be identified as the
Author of this work has been asserted in accordance with
the Copyrights, Designs and Patents Act 1988.

ISBN 978 1 4456 6838 3 (print)
ISBN 978 1 4456 6839 0 (ebook)

British Library Cataloguing in Publication Data.
A catalogue record for this book is available from the
British Library.

Origination by Amberley Publishing.
Printed in Great Britain.

Introduction

The name Surbiton conjures up visions of a neat London suburb with nice cars and smart lawns, the epitome of suburbia, that 1930s creation still existing in a time warp today, but there is much more than that to Surbiton. The name Surbiton does not derive, as many people think, from 'suburb', but from 'south bereton'. The estate of Kingston had two 'beretons' or granges where grain was collected and stored. These north and south beretons became Norbiton and Surbiton. The first reference to the name Surbiton is way back in 1179, and the name was spelt variously as 'Suberton', 'Surbelton' or 'Surpleton', among many others.

The first important mention of Surbiton in history is in 1648 when a skirmish took place on Surbiton Common, just south of Kingston. It was a Royalist defeat and the last battle of the Civil War. At the time, Surbiton was just a small hamlet with a few cottages, although that began to change in the eighteenth century. Along with Wimbledon and Kingston Hill, Surbiton became a place where wealthy Londoners built country houses. In the early eighteenth century, Surbiton gained a reputation as a place where mistresses were kept for country visits, but also as a spa. The area known as Seething Wells had natural warm springs where the water could be taken for medicinal purposes.

The great change came upon Surbiton with the coming of the railway in 1838. The London to Southampton railway came by Kingston, but the River Thames and objections from Lord Cottenham, who owned land in the Raynes Park area, meant that the line passed to the south of Kingston by a fair way, cutting through Surbiton Hill instead. For people wishing to live in the country but commute to London, houses closer to the new station of 'Kingston-on-Railway' were desirable and a man named Thomas Pooley bought much of the land around the new station to develop as a new town. Mr Pooley laid out streets and started to borrow money to build. He hoped to lay out a market area as a town centre but was prevented by Kingston Borough's taking him to court in 1840 to prevent this. (Kingston has a charter of Charles I from 1628 that forbids any other market within 7 miles). The idea of Surbiton as a town was slow to get off the ground and Pooley got into financial difficulty as rents from houses built failed to cover his loans, which Coutts Bank eventually called in. Following his bankruptcy in 1844, it was Coutts Bank who reaped the rewards of Pooley's vision. They built St Mark's Church in 1845 and Surbiton really began to grow in the 1850s when it also got its own local government.

Surbiton was part of the borough of Kingston but the residents thought that they were paying a lot in rates for very little return in the ways of roads, drainage and other services. In 1855 a group of local worthies obtained an Improvement Act, which set up a board of commissioners for Surbiton to run their own affairs. In 1894 this became an Urban District Council and in 1936 it became a borough, with a charter given by Edward VIII. On both of these occasions, Kingston had tried to regain control, which they finally managed in 1965 with the setting up of the new Royal Borough of Kingston upon Thames, which incorporated Surbiton as well as the Maldens & Coombe.

Surbiton thrived as a commuter town with a great expanse of housing being built in the 1920s and 1930s, mainly in the Berrylands and Tolworth areas to the south, but it also had

its own small shopping centre and local industries. Apart from the bombing of St Mark's Church, it escaped the war fairly lightly and it has succeeded in maintaining its individual identity. That identity has frequently been tinged with something scandalous alleged to be going on behind closed doors and net curtains, as mentioned in the novels of local author, Wendy Perriam. While the BBC comedy *The Good Life* in the 1970s portrayed Surbiton as a most respectable place (despite not actually being filmed in Surbiton), at the same time ITV broadcast a drama about Phyllis Dixey, the first West End striptease artiste in the 1940s who hailed from Surbiton. With its perceived lack of real history, some locals have invented a mythical history for Surbiton featuring characters such as the Goat Boy of Seething Wells.

Today, many of the big Victorian houses have been replaced by flats and there is a large student population, but it is also full of young families. There is a Bohemian edge similar to Islington in north London with plenty of gastropubs, coffee shops and other 'artisanal outlets' where old suburbanites mix with a new hipster generation.

I hope this collection of photographs will give the reader a good idea of what Surbiton was, how it has changed over the years and what it is today: a very pleasant small commuter town on the outskirts of London.

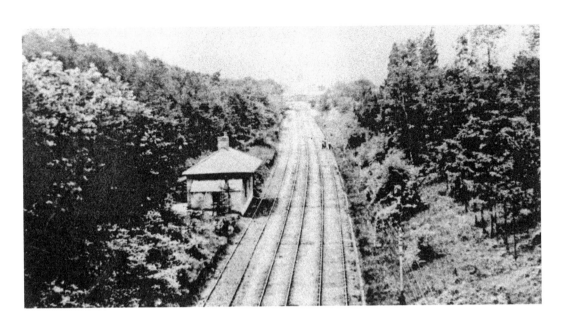

The Start of Surbiton

Although people did live in Surbiton before the coming of the railway, it was the opening of this tiny station, initially called Kingston-on-Railway, which led to the development of the town. The station opened in 1838 in the Surbiton Hill cutting, with five trains a day running between Nine Elms (Vauxhall) and Woking. The line went through to Southampton in 1839 and up to Waterloo in 1848. The station buildings moved to the present site in 1845 and were enlarged in the 1860s. The name changed to Surbiton when Kingston got its own station in 1863. The new Surbiton Station was completely rebuilt in the art deco style in 1937.

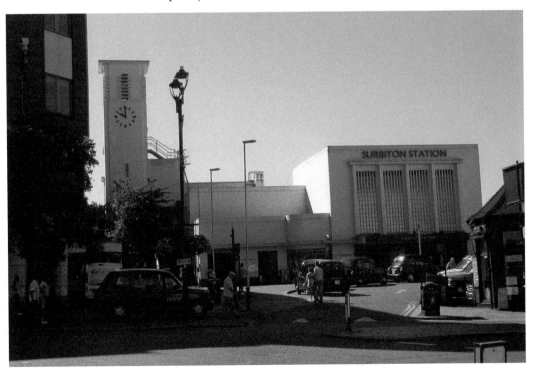

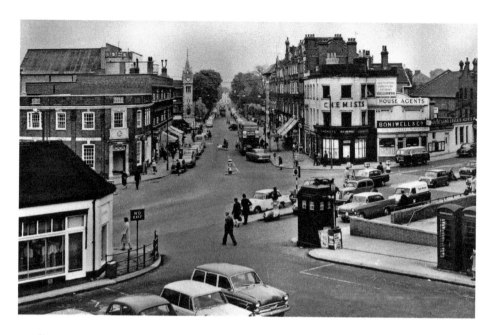

Tardis seen in Surbiton!

The original view was taken in around 1960 from the roof of Surbiton station above where Sainsbury's is today. We are looking down Claremont Road towards the clock tower. St Mark's Hill is to the right and Victoria Road to the left. This busy junction now has a roundabout. Bonniwell & Co., the estate agent, took over the chemist premises as well, but today the buildings are empty and being refurbished. Police telephone boxes were introduced in the 1930s and were still a common sight when the BBC series *Doctor Who* began, using a time-travelling spaceship called the Tardis, disguised as a police box. They were phased out by 1970 when police could get in touch more easily with each other using walkie-talkies. The modern photograph is from a lower level as the station roof can no longer be accessed.

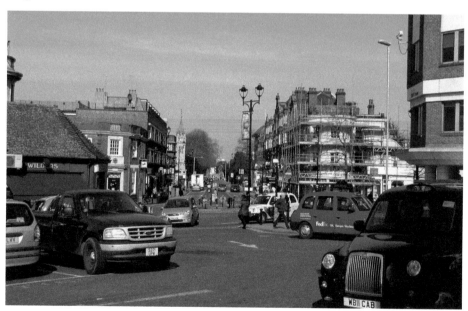

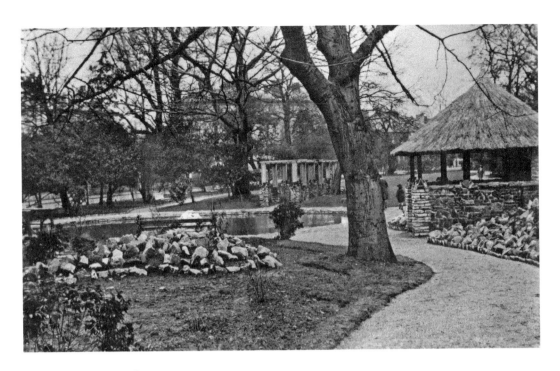

Claremont Gardens

Claremont Road and Claremont Gardens were part of the initial town layout of Surbiton by Thomas Pooley in the 1850s. He had bought up much of the land around the new Kingston-on-Railway station and began to build houses, a few of which survive to this day. Claremont Gardens was originally surrounded by an iron fence and was for the private use of residents only. Coutts Bank took over the development and, by the time of this Edwardian postcard, the park was open to all. It is not certain at which point the railings disappeared.

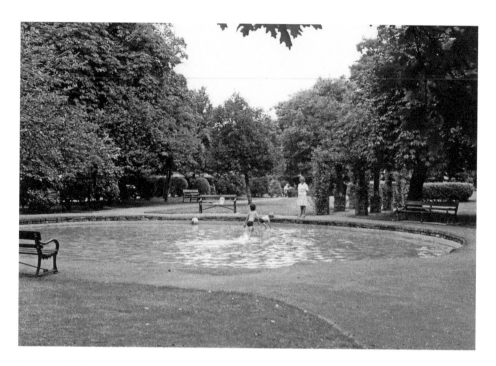

Fancy a Paddle?

In 1935, Surbiton Council bought the gardens as a public amenity. They removed the fountain and the large central pond became the place to sail model boats. By the 1960s, when the above photograph was taken, the central pond had become a paddling pool, following the change in children's preferred leisure activities. The gardens were remodelled in 2006 with a much smaller pond to attract wildlife and a 'Beetle Hotel'. It is rather overgrown today and could do with a tidy up.

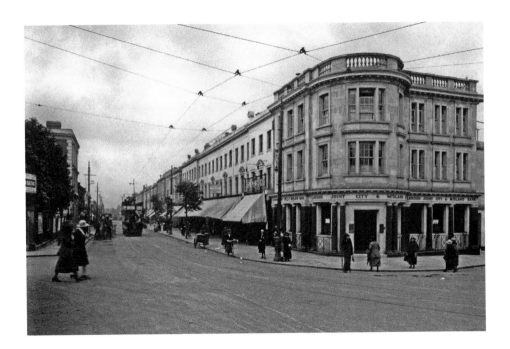

Electric Transport

Surbiton station is just to the left of this photograph looking down Victoria Road. The old photograph is from around 1920 and Surbiton trains are now electric rather than steam. The other form of electric transport is the tram in the background, responsible for the overhead wires obscuring the sky. Trams arrived in 1906 and were replaced by trolleybuses, which kept the overhead wires but dispensed with the rails, in 1931. The London Joint City and Midland Bank was renamed simply the Midland Bank in 1923. It was taken over by The Hong Kong and Shanghai Bank in 1992 and branches were renamed HSBC in 1999.

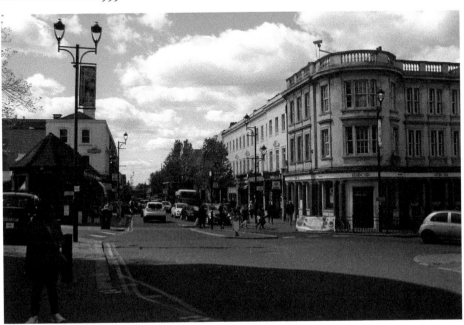

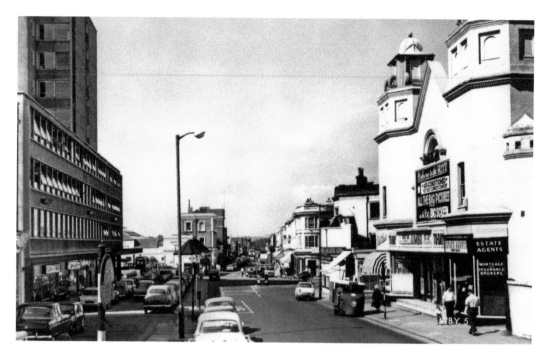

Nudity at the Coronation

The splendid building on the right in these photos is the Coronation Hall at No. 7 St Mark's Hill. The coronation referred to is that of George V. The hall opened as a cinema and lecture hall the day before his coronation in 1911. It struggled after the Second World War like many cinemas, despite renaming itself The Roxy in 1947 and The Ritz in 1965. It closed in 1966 and became a bingo hall. Great was the excitement when it became a naturist club in 1993, but this was a short-lived venture and it is now a Wetherspoon's pub, which opened in 1997 as The Coronation Hall again.

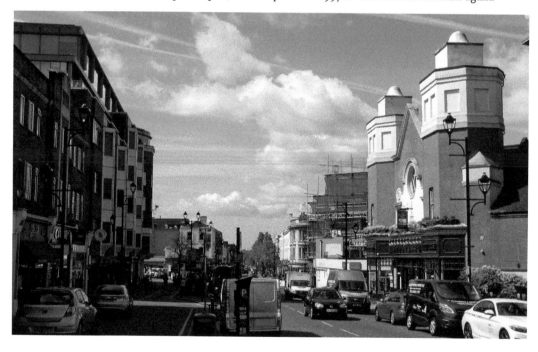

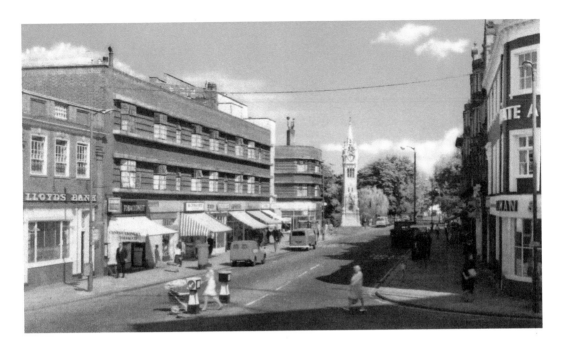

Claremont Road

Returning to our view down Claremont Road from near the station, the above picture was taken in 1973 when the author was a small boy. I love the old-style pedestrian bollards, the postman's van and the lady pushing a pram. Also note the lack of traffic. It was not that long ago but, of the businesses across the road, only Lloyds Bank is still there. S. Frost, the butcher was at No. 7, where Village Pizza is today. They won an industry award in 2015 from the Pizza, Pasta and Italian Food Association. Notice also that another level has been added to the flats above.

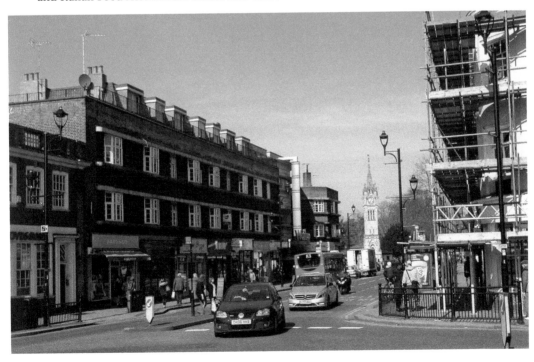

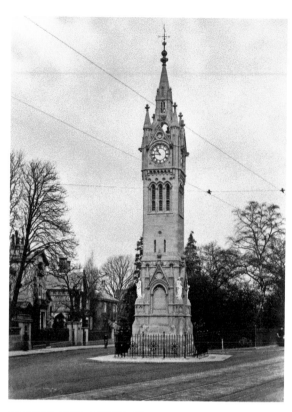

Surbiton Coronation Clock Tower

When Edward VII was crowned in 1902, the chief medical officer, Dr Owen Coleman, took it upon himself to launch an appeal for a memorial in the form of this clock tower. He struggled to raise the funds however, and the monument was not finished until 1908. A bronze roundel of Edward VII was later placed on the clock but no mention was made of the coronation as it had happened so many years previously. This was remedied in 2008 when the clock was restored and unveiled by Prince Edward, Earl of Wessex. Originally there were four statues near the base of the clock but it is not known when or why these disappeared. The aircraft contrails in the modern photo are a nice reflection of the overhead tram wires in the original.

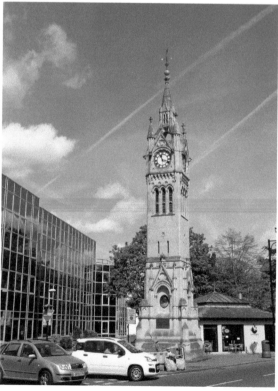

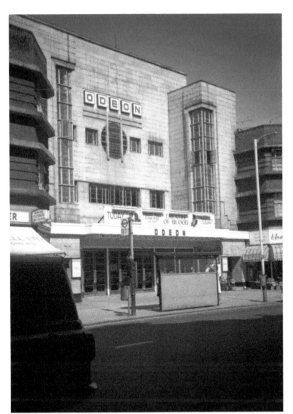

Horror in Surbiton

The Odeon in Claremont Road opened
in 1934 with my favourite Errol Flynn
film, *Captain Blood.* Here, in 1973, it
is showing *Theatre of Blood*, which
starred Vincent Price and Diana Rigg
in a gory horror film featuring murders
taken from Shakespeare's plays. Two
years later, the Odeon closed, a victim
of colour televisions in people's homes.
It was followed by a carpet company
and then a B&Q DIY store for a few
years before it was demolished to be
replaced by Waitrose in 1998. The
stylish 1930s flats to either side are still
there and there is still a handy bus stop
out the front.

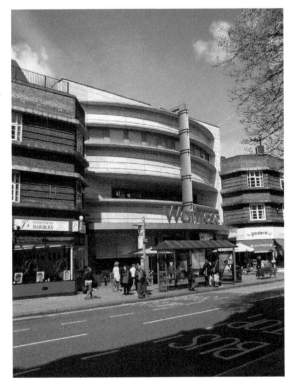

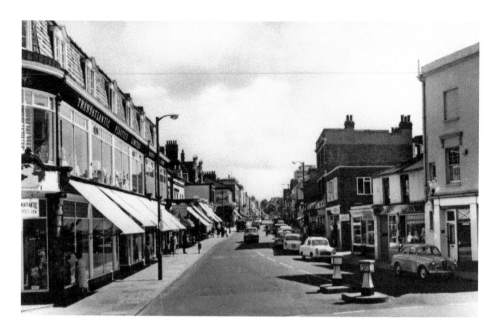

Transatlantic Plastics

Transatlantic Plastics were originally based at No. 29 Victoria Road but moved to these premises at Nos 45–51 Victoria Road in 1963. They were polythene converters, which means they made a lot of plastic carrier bags and other polythene products, and they lasted until 1977. There are various offices above now and shops below, including the award-winning Regency Bookshop, which has been at No. 45a since 1961 and is a great asset to the community with many talks and book launches. On the opposite side of the road, all the small shops have gone to be replaced by the new YMCA building, which was erected in 1984. The YMCA celebrated 140 years in Kingston and Surbiton in 2014.

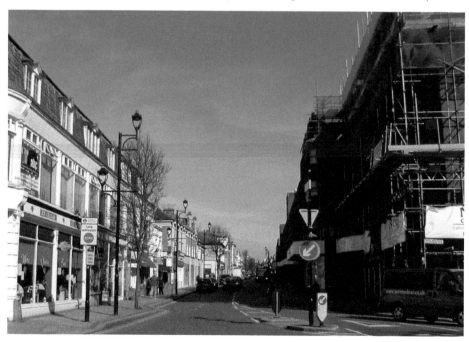

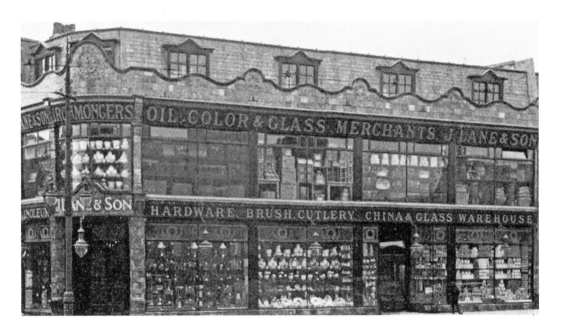

Lane & Son, Ironmongers

Long before Transatlantic Plastics and the Regency Bookshop, in 1908 the whole of this elegant building was an ironmongers, hardware store and, indeed, general merchant, as can be seen from his shop front. This was John Lane & Sons, who were there from the 1860s until 1923. Today it is Ex Cellar (now numbered as Nos 18–20 Brighton Road rather than No. 51 Victoria Road), which opened in 2012 as the third branch of this café and wine bar; there are others in Ashtead and Claygate, while further to the right are Leon Hair & Beauty and Emma's Nails (No. 47a Victoria Road).

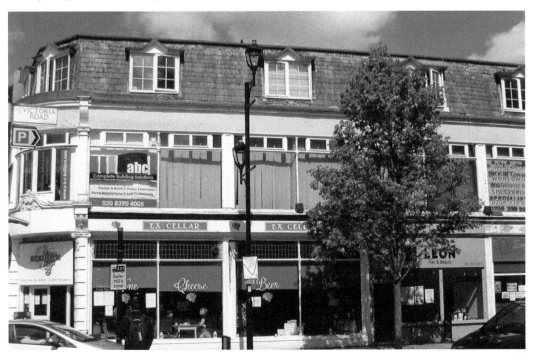

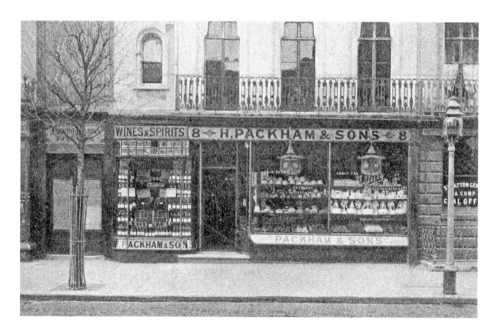

Packham's

H. Packham & Sons were a bakers and confectioners who also sold wines and spirits. They had premises at No. 24 Berrylands and here at No. 8 Victoria Road from the 1880s. In around 1908 they also opened a catering branch at No. 124 Ewell Road. Business boomed and a further premises was opened at No. 22 Claremont Road and they became 'refreshment contractors'. By the 1930s everything seemed to have gone wrong and they were reduced to being simply a baker's shop at No. 8 Victoria Road again. This lasted until 1983 when it was taken over by Coombes the bakers, although it continued to be known as Packham's. Doddle parcel services replaced Phones 4u at this site in 2014.

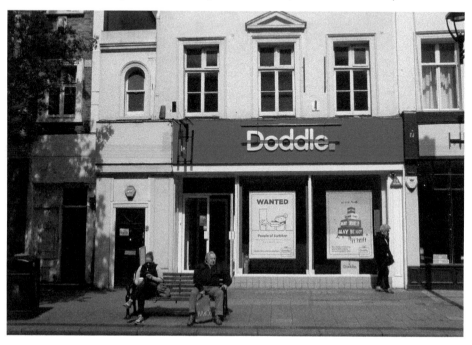

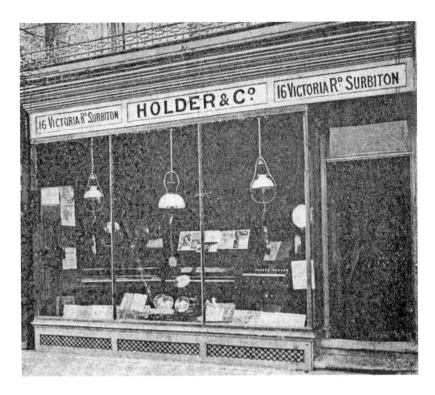

We Made our Own Entertainment

At the end of the working day or when guests were present, Victorian, Edwardian and later families would often gather round the piano and enjoy themselves, so Surbiton needed a piano shop. This was provided by Holder & Co. John Holder opened his first shop at No. 46 Surbiton Road and moved here, to No. 16 Victoria Road, in 1903 or 1904. They became general music dealers in the 1930s but, as time went by, more people preferred to buy records or listen to the radio rather than make their own music and the shop closed in 1967. It is now the middle section of M&Co. Clothing, which occupies Nos 15–17 Victoria Road.

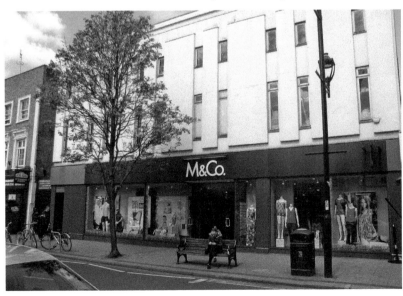

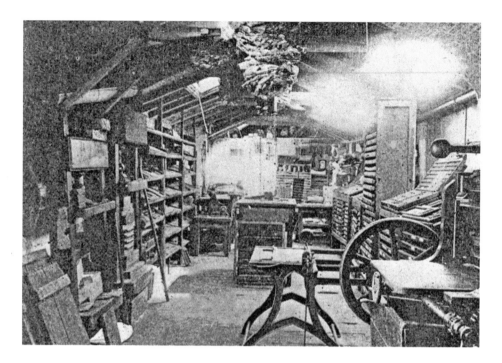

Bull & Son

This is a rare interior view taken at No. 20 Victoria Road in around 1890. It is a printing works and the home of Bull & Son, printers and stationers. They had already been on the site for over twenty years when the photograph was taken since they were founded in 1864, very early on in Surbiton's shopping history. They celebrated their centenary at this address and in 1967 they moved to No. 9 Cleaveland Road. It is not known when they ceased trading. Today, the 'beauty' and 'baby' sections in Boots occupy the 'shed' behind the premises.

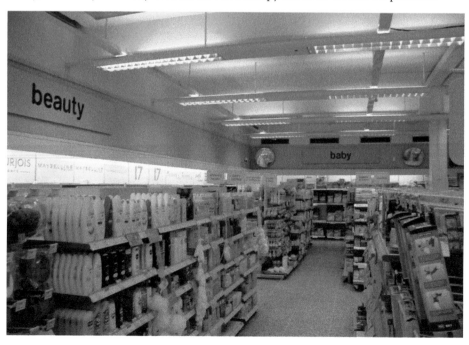

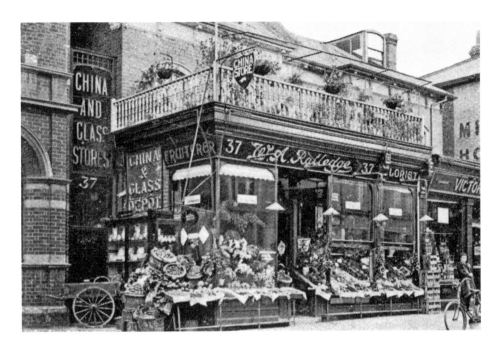

Ratledge

W. A. Ratledge occupied No. 37 Victoria Road from the late 1880s. He began as a dealer in china and glass, which was stored on the upper floor, but also sold fruit and vegetables and flowers. He seems to have given up on the china and glass during the First World War, and by 1922 he had also given up on the flowers, being listed in local directories as a fruiterer until closing in 1938. Today the balcony railings have gone (probably in the Second World War when scrap iron was collected for the war effort) and it is a branch of Foxtons Estate Agents.

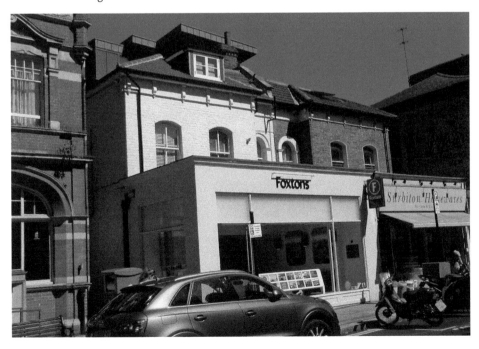

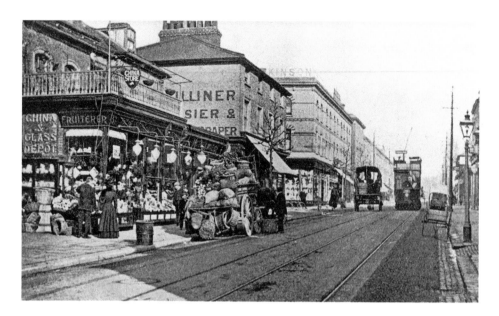

Victoria Road in 1910

Here is Ratledge's again, in 1910, looking down Victoria Road. He is taking a delivery from a very overloaded horse and cart. Another in the distance passes a tram. The milliner, hosier and draper on the left is Williams & Co., at No. 35. They were there from *c.* 1910, when this photograph was taken, until the Second World War. Today it is Surbiton Art & Stationery, although the faded writing on the side wall tells us that it was once a 'Do It Yourself' store. Next door at No. 36 was the Victoria Wine Company. They were in Surbiton from the late 1870s right through until 1998. Now it is Surbiton Hairdressers, with Simplicity beauticians beyond.

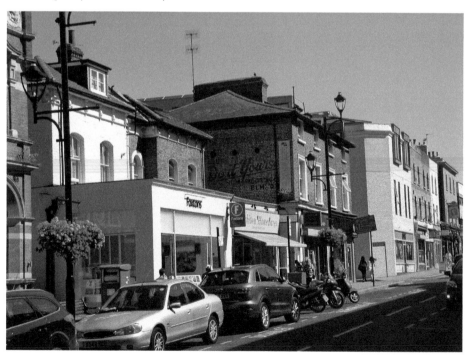

The Original Post Office

This glorious Victorian building proudly declares that it was built in AD 1898 when post offices, along with banks, were the showiest buildings on the high street; in this case at No. 38 Victoria Road. Since 1974, when the old photo was taken, the Post Office has moved out of many of its magnificent buildings including Kingston, Wimbledon and Surbiton. In Surbiton, it moved out in 1995 and is now located within a shop at Nos 2–3 Victoria Road. Since the earlier photograph, a third rather attractive oval window has been added at the top of the building in the centre, and Zizzi's Italian restaurant occupies the site.

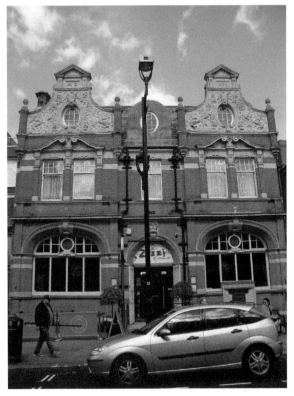

Kingston Borough News

The *Surrey Comet* is the local paper of choice for the royal borough these days, but there have been rivals in the past. The *Kingston Borough News* came out in 1962 and lasted until 1980. It was a tabloid paper seemingly inspired by *The Sun* and *The Daily Mirror* of the day, although it did cover local news well. This is its small office in 1967 at No. 7 Brighton Road. Headlines featured include 'Councillors Fight New Power Charges' and 'Man Drove While Drugged!' but more prominence is given to a large photo of an attractive young local lady, one of the 'Friday Girls' the paper regularly featured. In 1980 the *Surrey Comet* took it over and continued with it as a mainly sports-based *Wednesday Comet* until the 1990s.Today the premises are part of The Copper Kettle restaurant, which also owns the premises to the right of the photographs.

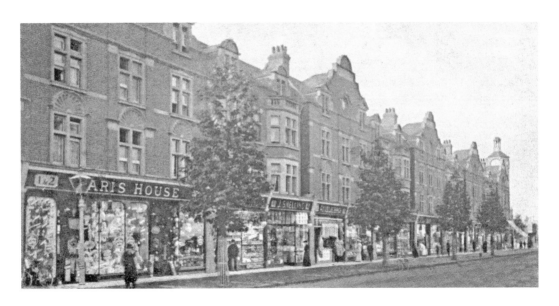

Electric Parade

Electric Parade was built in Brighton Road in 1904–05 just when electricity arrived in Surbiton. Here we see Nos 1–5 Electric Parade, which are now Nos 27–35 Brighton Road. The Paris House was a fashion outlet run by William Mathew. Next door is a chemist, Lewis and Burrows. Their premises closed in 1909 and were taken over by the neighbours on the other side, Snelling, a stationer. Then there is a butcher, Ainslie, with pigs hanging up outside. The parade of shops was renumbered in 1910. Of the original shops, Snelling and Ainslie lasted longest, until the 1920s, with Ainslie being taken over by Dewhurst's, another butcher.

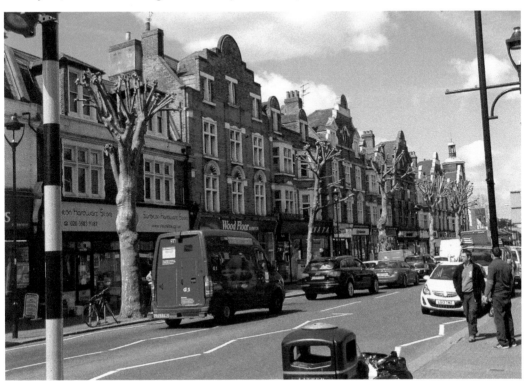

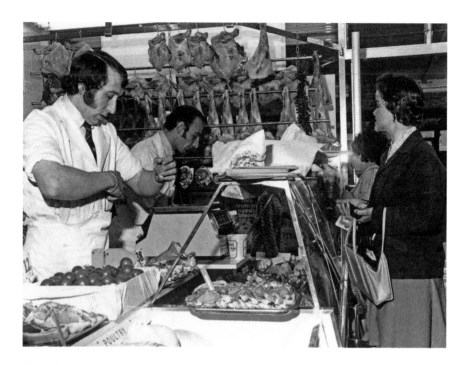

Dewhurst's

This well-loved chain of butcher shops began as a family firm before the First World War and was bought in 1920 by the Vestey Brothers. They continued to expand and the Surbiton shop took over Ainslie's butchers in 1924. When this photo was taken in 1973 Dewhurst's were at their peak and ran over 1400 shops. They were the first butchers to introduce glass windows rather than having the meat out in the open. Pressure from supermarkets forced Dewhurst's out of the market entirely by 2006 although there has been talk of the name being revived for in-supermarket franchises. No. 35 Brighton Road is now Surbiton Fish & Chips.

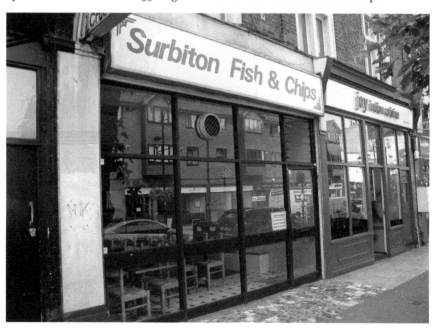

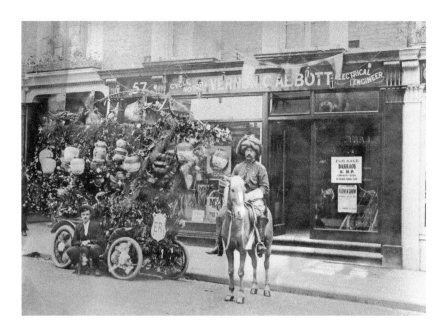

Bengal Lancer Sighted in Surbiton

Vernon Abbott was a bicycle seller and electrical engineer at No. 57 Brighton Road, previously known as No. 8 Upper Brighton Terrace. Here he has decorated a car with flowers and Chinese lanterns to take part in the grand parade and pageant marking the coronation of Edward VII in 1902, Mr Abbott himself is dressed rather splendidly as a Bengal Lancer, one of the more famous regiments of the British Indian Army, colloquially known as 'Skinners' Horse' as two regiments were originally raised by Colonel James Skinner in 1803. The regiment still survives in today's Indian Army. The Indian theme continues today with the Guru Express Takeaway.

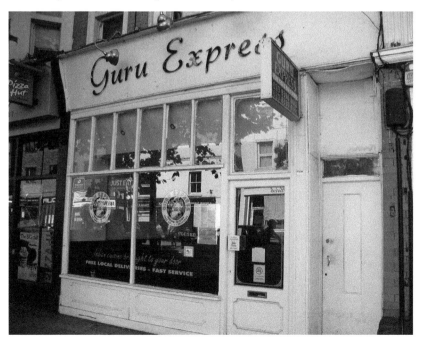

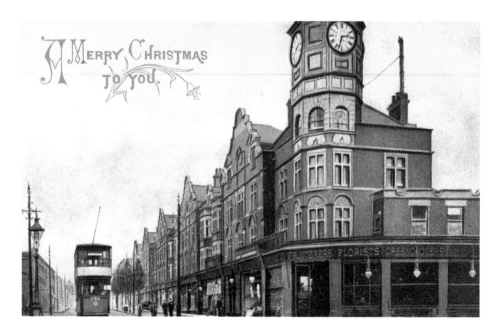

Electric Parade – Again

This is Electric Parade in Brighton Road viewed from the other direction. These shops were numbered 18, 17, 16 Electric Parade etc. into the distance and are now Nos 57, 55 etc. Brighton Road. At No. 15 was the aptly named baker's shop F. J. Baker. The grand clock tower was surmounted by a globe but it was badly damaged by a V-1 flying bomb in 1944 and replaced with a simple campanile. In Edwardian times it was quite fashionable to have rather ordinary postcards like this overprinted with a Christmas greeting. They could be posted on Christmas Eve in the morning and would be delivered in the afternoon.

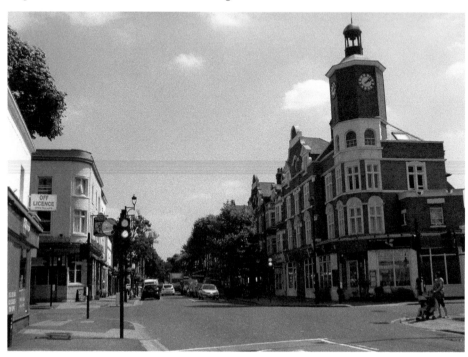

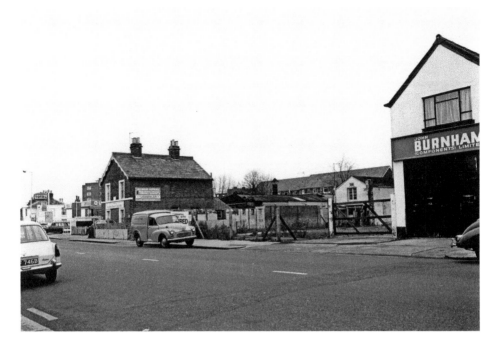

Nuclear Surbiton

Nos 78–84 Brighton Road was a building site in 1974 following the demolition of Grist Plastics, which had been there since the war. It was replaced by Chesham Court flats. John Burnham Components at Nos 72–76 made parts for air conditioning and refrigeration systems. It amalgamated with Hotfrost and still occupies the site today. Before that, it was John Cooper & Son, woollen merchants, in the mid-1970s, and before that, in the 1960s, Palatine Industries manufactured nuclear equipment on the site, which sounds rather sinister.

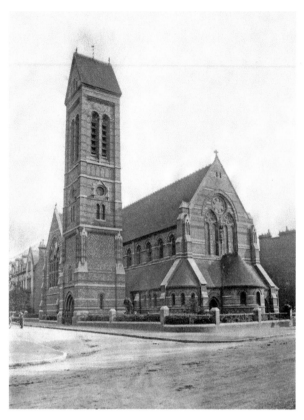

St Andrew's Church

Like so many churches in the nineteenth century, St Andrew's began as a temporary iron church to cope with the increasing population in St Mark's parish. This opened in 1860, and the stone church was consecrated in 1872. The large tower, which is almost completely separate from the church, was dedicated in thanks for the recovery of the Prince of Wales from illness in that same year. St Andrew's remained a separate church in the parish of St Mark's until 1933 when it became its own parish. Shortages of clergy forced the two parishes to merge again in 1977. The photograph from *c.* 1900 shows the wrinkles that often affect old collotype prints.

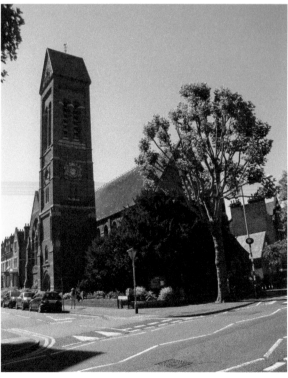

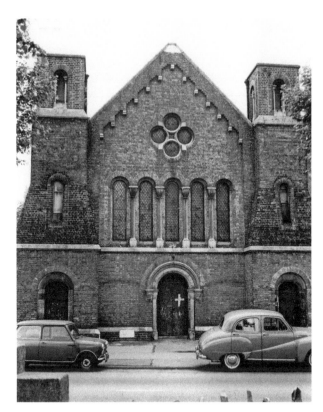

Maple Road
Congregational Church

This church, on the corner of
St Leonard's Road, was founded
by Revd Byrnes (from Kingston
Congregational Church), William
Leavers and Revd Richard
Smith, in whose house the early
congregation met in 1853. The
church was built in 1854 at a cost
of £2,340, helped by a £1,000
donation from Mr Leavers. It was
a very popular place of worship
and within ten years a new,
larger church was built on the
Maple Road/Grove Road corner.
The original church became the
Sunday school and lecture hall.
It ceased this usage in the 1970s
when the Surbiton church merged
with Kingston and it became a
warehouse at the time of the old
photograph. Now it has been
converted into private housing.

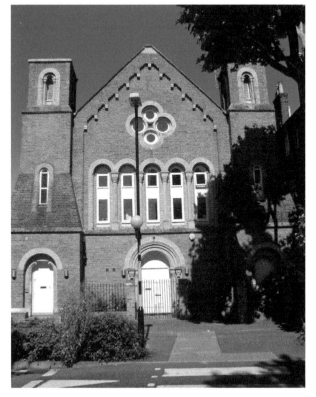

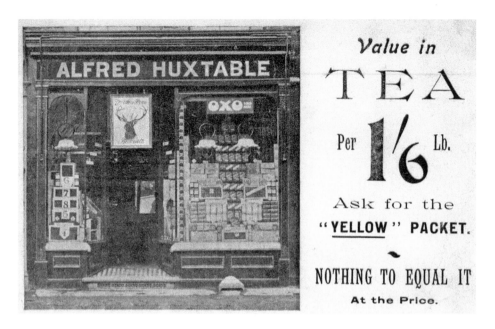

Value in
TEA
Per **1/6** Lb.

Ask for the
"YELLOW" PACKET.

NOTHING TO EQUAL IT
At the Price.

Alfred Huxtable, Grocer

Alfred Huxtable was a bit of a local legend when this photograph was taken on his retirement in 1954. He had been at No. 95 Maple Road for just over fifty years running his grocer's shop. His successor, Mr Mackenzie, lasted barely a year, as did the next man, Mr Metcalfe, who gave up in 1958. From 1960 it was run more successfully as Maple Stores by Rose & Co. Today it is a new branch of Ward & Cross Ltd Hairdressers, which opened in 2015. There is an original sign (not visible in the photographs) that states that this terrace was originally named Lucknow Place, after a siege in the Indian Mutiny.

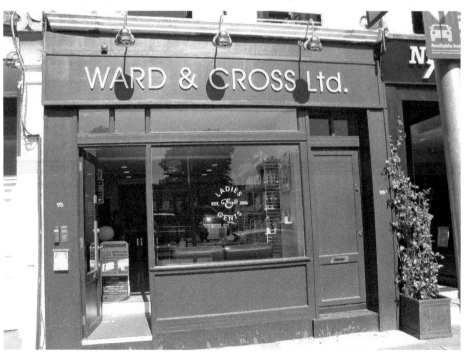

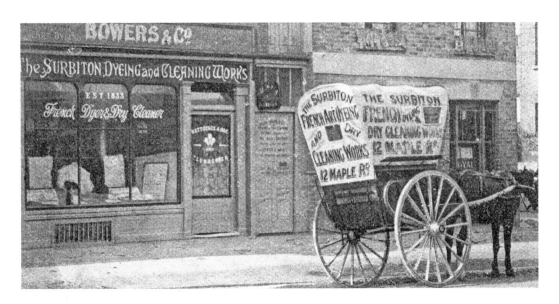

French Cleaners

The Surbiton Art, Dyeing and Dry Cleaning Works dates its establishment to 1833 when Surbiton didn't exist as a town, but this is the foundation date for the firm in France. Mr G. Boura came to England and opened his shop in the Brighton Road in the late 1880s as Boura & Fils, but moved to Maple Road in 1901. In 1906, he anglicised his name to Bower. His son, Henry Bower (later Bowers) ran this cleaning works from 1911 when the road was renumbered and No. 12 became No. 73. The firm lasted until 1966. Today it is the Maple Works Flexible Shared Workplace, which can be hired out for use as offices. To the right is the Gordon Bennett bar, formerly The Royal Charter.

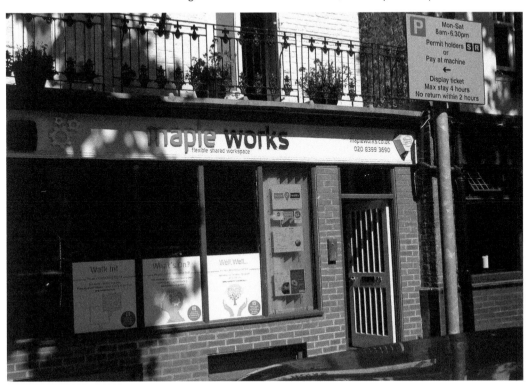

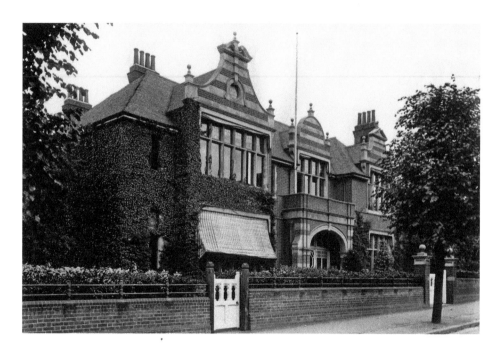

New Balls Please

The Surbiton Club was founded by a group of local gentlemen in Victoria Road in 1870 to act as a meeting place and social club. In Edwardian times it moved to these splendid premises in St James' Road. Originally a gentlemen-only club, it once rejected Frank Bentall of Bentall's in Kingston because he was 'only a tradesman'. All men – and ladies – are now equally welcome and there is a large and varied programme of events as well as an excellent bar and three snooker tables. Looking at these pictures, one is tempted to ask: where did all the stone balls go? Two large ones on the gate and six small ones on the roof have all disappeared, along with the right-hand set of chimney pots. The extension to the left doesn't do much for the aesthetics of the building either.

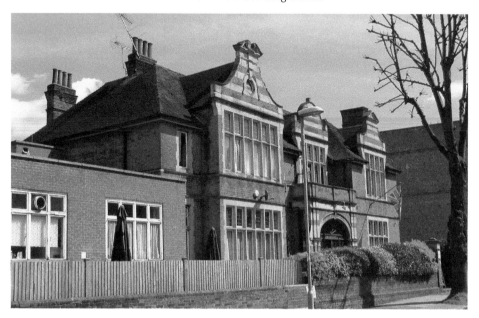

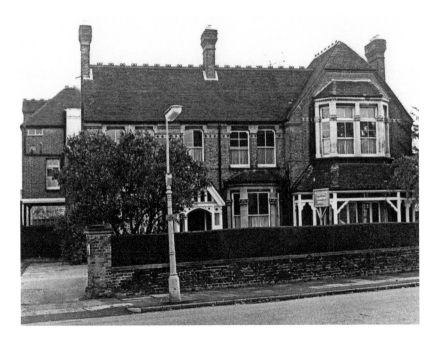

Surbiton Cottage Hospital

In 1870, thanks to the efforts of Mrs Frederick Howell, Surbiton gained a cottage hospital many years before Kingston. The initial site at York Villa in Victoria Road (the site of the old Post Office and today's Zizzi's) was soon deemed inadequate, and this building was erected in St James' Road in 1882–83 for a cost of £5,000. Archdeacon Burney laid the foundation stone. When the Surbiton Voluntary Hospital was built in the Ewell Road in 1936, the Cottage Hospital became the Surbiton Annexe to Kingston Hospital, caring for the chronically ill. After a large renovation, it was renamed the Claremont Hospital in 1951 and is pictured here in 1973. It closed in 1977, but this building was retained for a while as an NHS office before becoming privately owned. The other hospital buildings were replaced by housing in Ravens Close and Dolphin Close.

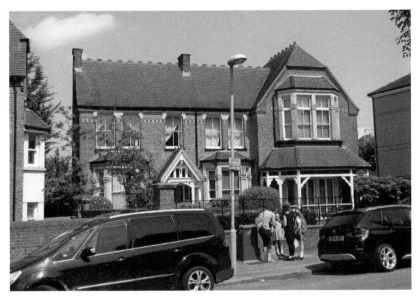

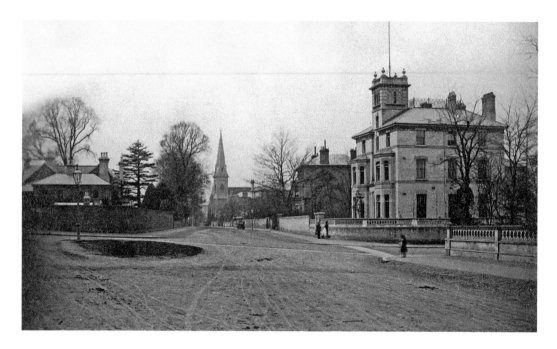

Maple Road in 1883

A rare early photograph of Surbiton looking down Maple Road from the junction with Claremont and Uxbridge Roads. It shows one of the large mansions built in Surbiton in the 1850s or 1860s. Notice also the 'muddy' street, which is probably mostly horse manure; a different form of pollution from the petrol fumes of today. The traffic island has gone and has been replaced by many traffic lights. In the distance is Surbiton's second Congregational Church, built in 1865 but demolished 100 years later when the church merged with Kingston. In fact, all the buildings in the original photograph have gone.

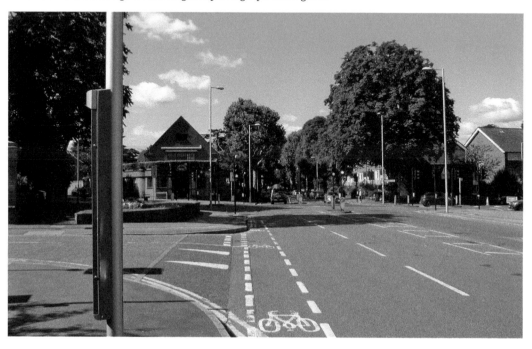

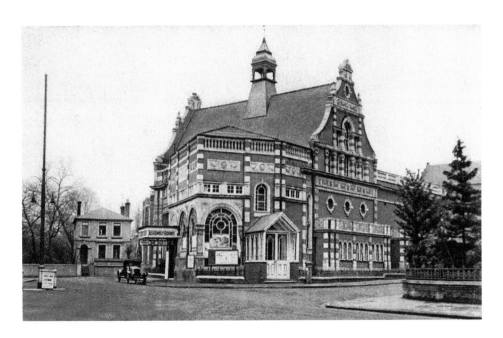

Surbiton Assembly Rooms

The Assembly Rooms were built at the third attempt by the citizens of Surbiton to erect a meeting place or hall. Six thousand £1 shares were successfully issued and the halls opened in 1889 on the site of the former Elmers House. The architect was Alfred Mason. It could cater for 800, with a stage, tea room and supper room. In 1894, the Duke and Duchess of Teck (later George V and Queen Mary) attended to see a tableau vivant – *A Dream of Fair Women*. This was put on to raise money for St Mark's Men's and Boys' Clubs. The mainstay of the halls became music concerts and amateur stage productions like those by the Genesta Club, which put on plays from at least 1900 to the early 1960s. R. C. Sherriff premiered a play here called *Mr Birdie's Finger* just before his more successful follow up, *Journey's End*. The beautiful architecture has been somewhat mangled by 1950s and 1960s additions to the front and the removal of the campanile.

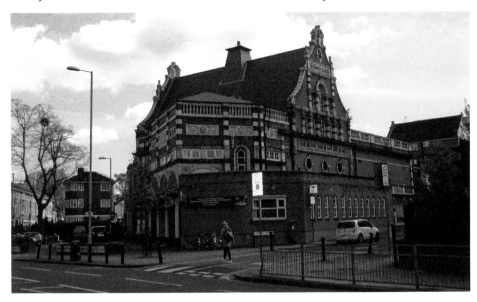

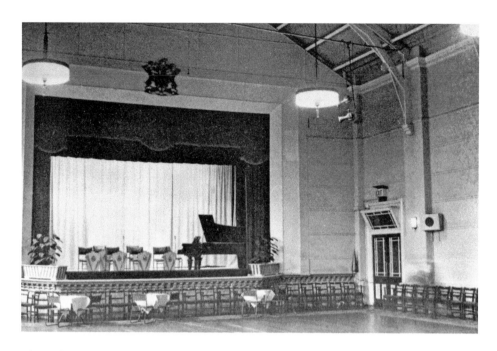

The Main Stage

This is the stage of the main hall in Surbiton Assembly Rooms where those concerts and plays were performed. Like other theatres and cinemas, the Assembly Rooms struggled to survive after about 1960, although it did diverge into rock concerts. Black Sabbath played here in 1970 and Nick Cave in 1984. In 1990, Kingston Borough sold the building to Surbiton High School, which needed more room, and the author attended many varied school events here when his daughter was at the school. The rooms are still available for outside hire when they are not being used by the school. There is a Stagecoach club for children on Saturdays, and a community church meets here on Sundays.

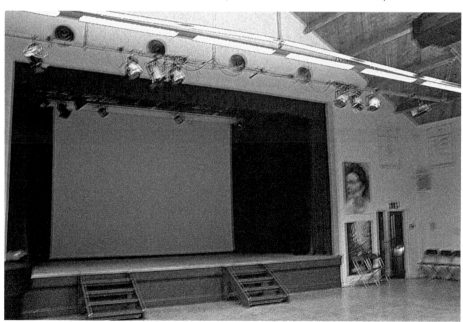

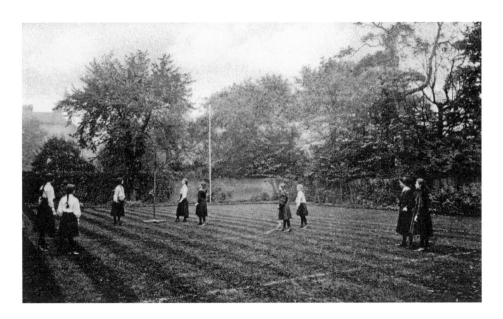

Surbiton High School Netball

Surbiton High School was founded in 1884 by a group of Anglican clergymen to educate girls. These men founded United Church Schools Trust, now United Learning, which runs a group of independent schools and academies. Surbiton High School was their first. 'Old girls' include Nicky Morgan MP, former Education Secretary; Chemmy Alcott the skier; and Mollie King from the pop group The Saturdays. The first buildings had no sports field so this netball match in *c.* 1910 is probably taking place on the field behind what was then Shrewsbury House School but is today's Surbiton Boys' Prep School. Shrewsbury House School moved to Ditton Road in 1910. Surbiton High School now owns seven different buildings in Surbiton and has sporting facilities in Hinchley Wood, which is where netball is played today.

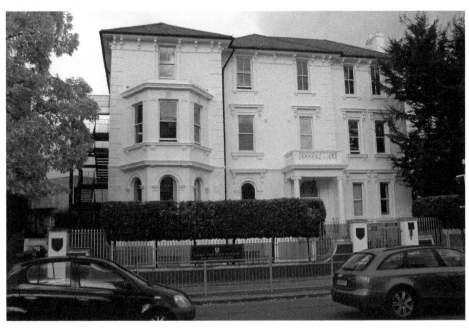

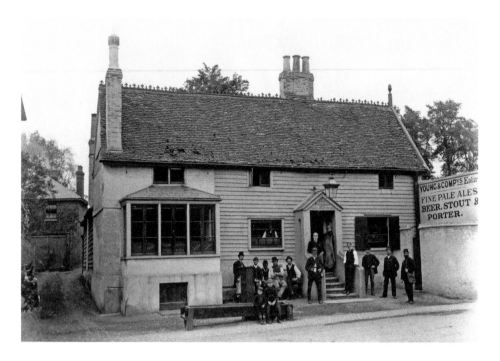

The Waggon and Horses

Just across from the Assembly Rooms on Surbiton Hill stands the Waggon & Horses. It was built as a convenient watering hole at the bottom of the hill, and a trace horse used to be kept here. Trace horses were hired out to passing wagons and coaches that could not manage the hill alone. Because this was a vital task, the pub has been here a long time. The earliest reference is 1689, when the pub was prosecuted for allowing Sunday drinking. The old photograph shows a Georgian building of 1812, which was rebuilt in the late Victorian period. In the 1920s and 1930s, the yard was rented by the famous Cooper racing cars.

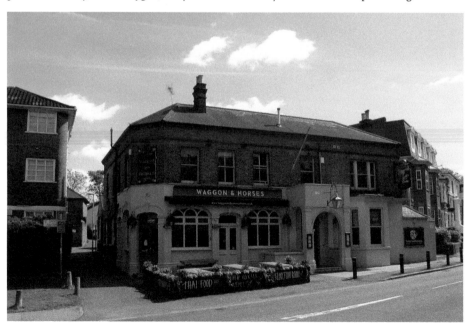

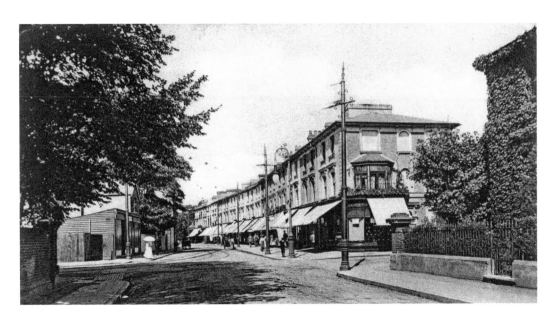

Surbiton Park Terrace

Surbiton Park Terrace lies on Surbiton Road, leading from Surbiton to Kingston. The building nearest to the camera is now No. 75 Surbiton Road. The middle windows of this terrace all had very elaborate stone framing but they have all now been removed except for those at Surbiton Groceries, giving the terrace a much plainer appearance. It was in Surbiton Terrace that G. T. Jones, a well-known Surbiton photographer, plied his trade. He was at No. 9, which was renumbered to No. 31 Surbiton Road in 1904. He had taken over the business of Samuel Fry, who had started photography there as early as 1865. The business was taken over by G. Chaplin Jones in the 1920s. The road was again renumbered in 1934, so No. 31 became No. 55. The business closed in the late 1930s.

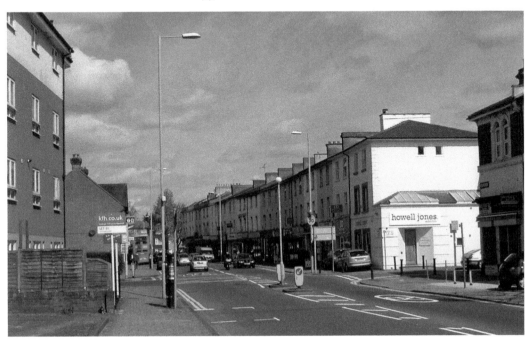

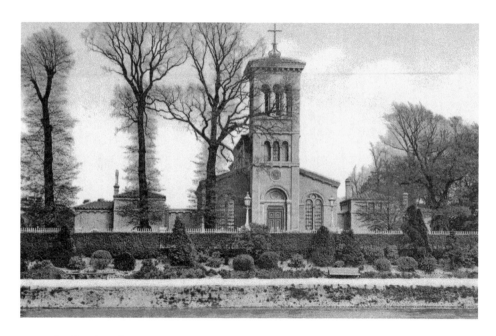

St Raphael's Church

Just north of the old Surbiton borough boundary (so strictly speaking in Kingston), lies St Raphael's Roman Catholic Church. This was built in 1846–47 as a private chapel for Alexander Raphael in the grounds of his estate, Surbiton Hall. After his death in 1850, it was opened as a place of worship for the few local Catholics at that time and soon grew into a strong parish, eventually being officially taken over by the diocese after the Second World War. Under threat from demolition in the 1960s, the church was listed, saved and renovated, and new rooms, including an Alexander Hall, have been recently added.

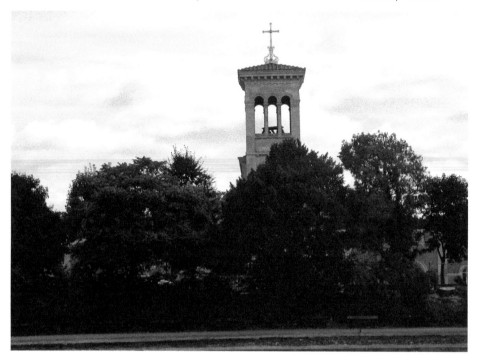

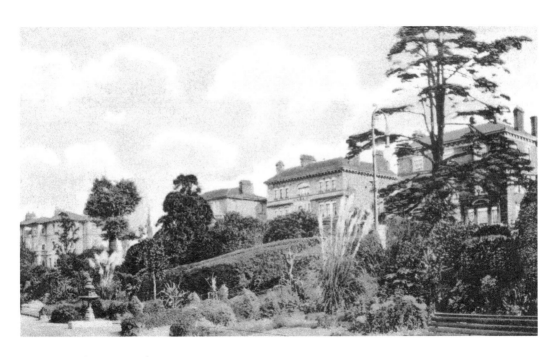

Queen's Promenade

Queen's Promenade looks absolutely splendid in this colour postcard of *c.* 1910 with the Portsmouth Road and grand houses behind. Originally the river had been dangerously undercutting the road here and Alderman Gould of Kingston organised that earth from the excavation at Chelsea Waterworks should be dumped here to form an embankment and promenade. It was opened in 1856 when Queen Victoria drove her carriage along it. She had not meant to take this route but the Borough closed Portsmouth Road and diverted her along the Promenade. She was not amused!

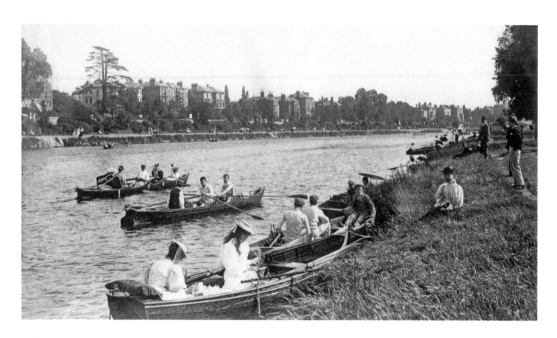

Jolly Boating Weather

The Thames had been Kingston's original highway for trade and had 1,000 years of industrial use before anyone seriously considered using it for leisure activities. The rise of the middle classes and the growth of free time led to the development of sports and leisure in many areas. Here we are looking across the Thames at the Portsmouth Road while several young Edwardian ladies and gentlemen are 'mucking about in boats' Rowing boats, punts and even gondolas could be readily hired from both Kingston and Surbiton. Jerome K. Jerome's *Three Men in a Boat* begins at Kingston. Today, the undergrowth makes it difficult to access the west bank.

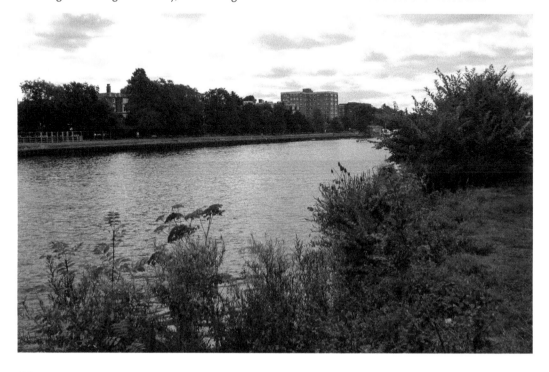

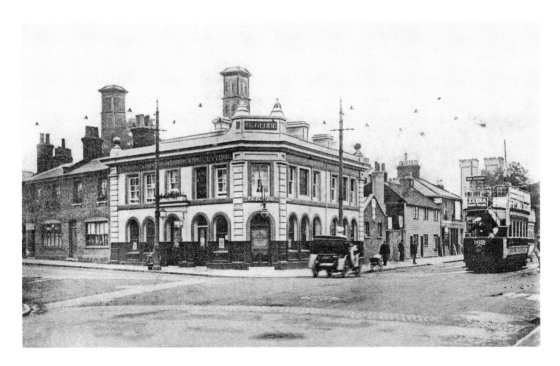

The Globe, Portsmouth Road

The Globe was originally the Seething Wells pub on the Portsmouth Road. It opened as a Hodgson's-run beerhouse in 1852 for the workers at the Chelsea and Lambeth waterworks. After a rebuild in 1867 from the original wooden structure, the beerhouse became fully licensed and able to sell spirits. It closed after a little less than 100 years and lay derelict for a while before becoming a car showroom in 1973. It is currently a Laithwaite's wine store but the building has changed little since the 1910 photograph. The large towers behind were part of the Chelsea Waterworks.

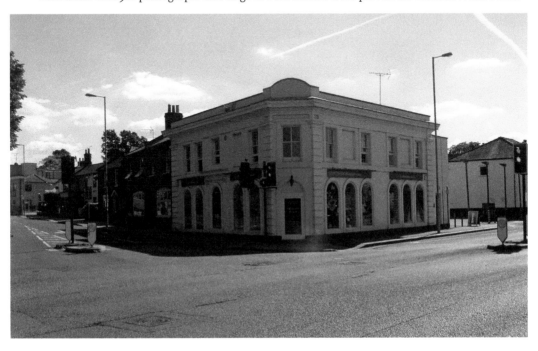

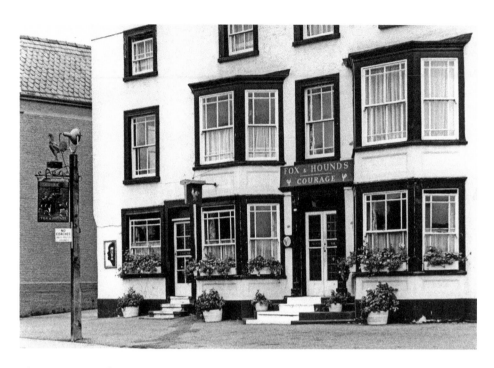

The Fox & Hounds

An alternative drinking den at No. 60 Portsmouth Road is The Fox & Hounds, also built here in around 1850, although it replaced an earlier pub on the Thames side of the Portsmouth Road, which dated back to the late eighteenth century. A Hodgson's pub since at least 1907, it was a Courage pub at the time of the 1967 photograph. It is now owned by Star Pubs & Bars, part of Heineken. The front terrace and tables were laid out in 1984.

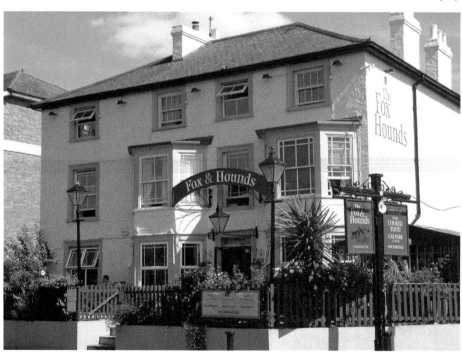

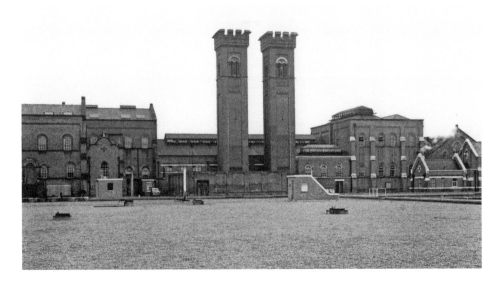

Seething Wells

Named after some hot springs in the area, Seething Wells is where Lambeth and, later, Chelsea Waterworks were built in 1849–52 to supply clean drinking water to those parts of London. Dr Snow used water from the Lambeth Works here and compared it with Battersea water to prove that cholera was a waterborne disease that could be prevented with a safe supply of clean water. The two towers have now gone and the filter bed has been built on, which is why the modern photograph has been taken much closer in. The buildings are shared between Kingston University and Nuffield Health, a private healthcare provider. In the early years of this century, Seething Wells has been threatened with further redevelopment but this appears to have been successfully fought off by those interested in the conservation of both the architectural heritage and the local wildlife.

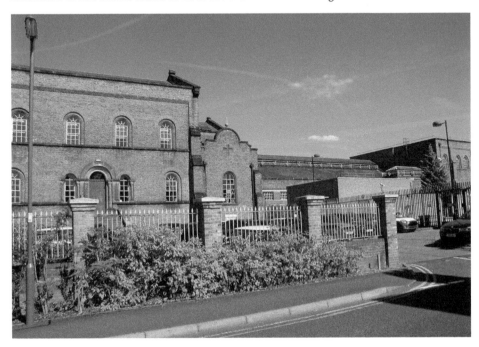

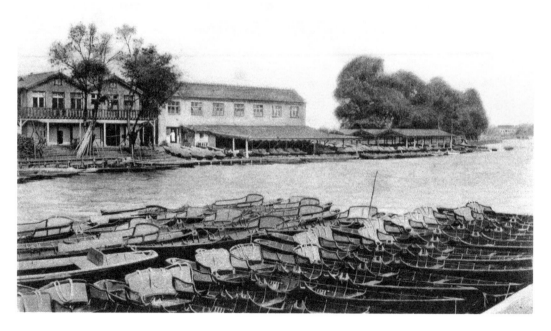

It was Called What?

The Thames used to be full of gravel eyots, small islands that appeared and disappeared with the tide and currents. Those that have survived were shored up and consolidated in Victorian times when the Thames was also dredged. The largest island in the Borough of Kingston is Raven's Ait, which was called Raven's Arse until the nineteenth century. A treaty was signed here in 1217 to get the French Dauphin (later Louis VIII) to leave England. He had been called in by the barons in their fight against King John, but John died in 1216, so the barons persuaded the French to leave. Today the island is used for weddings and other events but it can be difficult getting a boat across, unlike Edwardian times when there appears to have been plenty of punts.

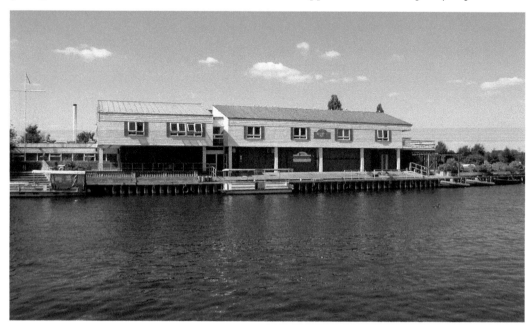

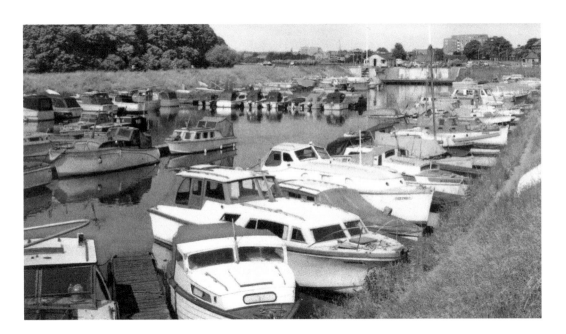

Thames Marina

Today this is known as Thames Ditton Marina (although it is in Long Ditton). It lies just over the southern borough boundary in Elmbridge Hundred in Surrey. It was founded in 1957, shortly before the early photo (above) was taken. Nothing much has changed. The two pictures are almost identical, despite the sixty-year gap. On the other side of the Portsmouth Road is a large garage, Coopers, which specialises in Minis. Back in the 1990s, they got into trouble for failing to give a job to a female apprentice when they had given positions to all their male apprentices.

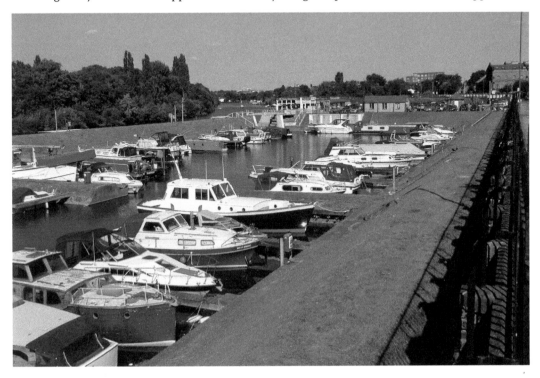

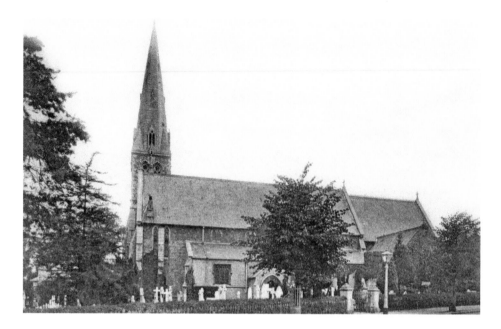

War Survivor

St Mark's parish church was built in 1844–45 at a cost of £5,500, mostly paid for by Coutts Bank, who took over the Surbiton Estate after Thomas Pooley became bankrupt. The bank was keen to develop the area and a church was essential. Surbiton grew so much that just ten years later the church had to be enlarged to cater for over 1,000 worshippers. The church also had its own cemetery, though this was closed in 1886. On the night of 2 October 1940, St Mark's was destroyed (with the exception of the spire) during the Blitz. The congregation met elsewhere until the post-war rebuilding could finally start in 1955. The rebuild was completed in 1960. St Mark's is now a combined parish with St Andrew's.

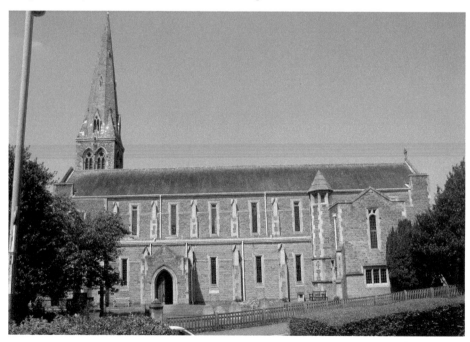

Vicars of St Mark's

Reverend Charles Burney was appointed vicar of St Mark's in 1870. He was one of those men who got things done. At the time of his appointment, St Andrew's (a daughter church of St Mark's) was a temporary iron structure, but Burney launched an appeal for a stone building. He persuaded Coutts Bank to donate the land and the church was opened in 1872 with all its seats free for the poor. He was also keen on schooling and promoted parochial schools in Surbiton and Kingston. He became an archdeacon of Kingston in 1879. He was also a founder and helped to run Surbiton High School for girls. The current vicar is Revd Robert Stanier, who was previously chaplain at Archbishop Tenison's School in Lambeth and has been in Surbiton for four years. He is also captain of the Southwark clergy cricket team.

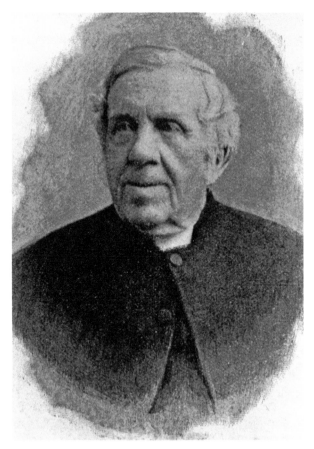

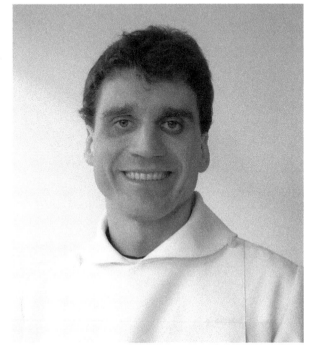

Surbiton Constitutional Club

Surbiton Constitutional Club was on St Mark's Hill, opposite the vicarage. It was opened in 1928, just as all women over the age of twenty-one finally became entitled to vote. The club, like other similar ventures, was founded to educate the newly enfranchised in the ways of the constitution, but also functioned as a social club and rooms, which could be hired out. It closed in 1995 and has become a set of apartments called St Mark's Lodge. The addition to the right of the building has unfortunately destroyed the rather lovely arched windows.

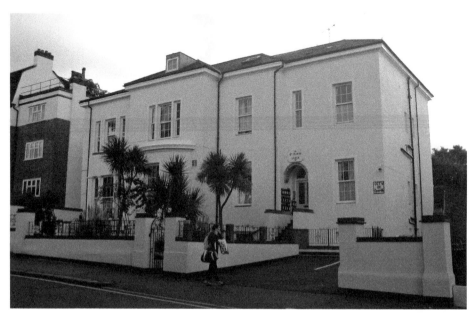

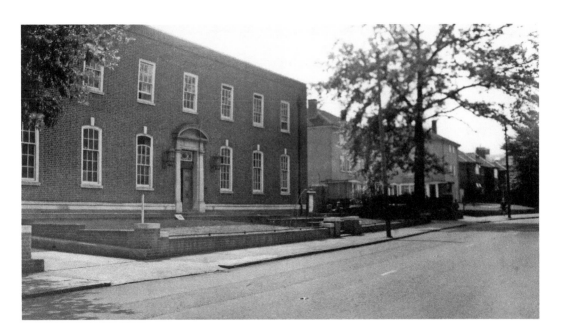

The Telephone Exchange

Surbiton's telephone calls were handled by Kingston until 1930 when this new exchange was built in the Ewell Road. Instead of calling it Surbiton, it was known as the Elmbridge Exchange, because it also handled calls throughout the Elmbridge area. For those of you who remember old telephones with the letter codes (before around 1968), the ELM translates into the 399 of most Surbiton telephone numbers today. With electrification and now computerisation, there is no need for large numbers of staff, and most of the exchange is now occupied by Surbiton Amateur Boxing Club.

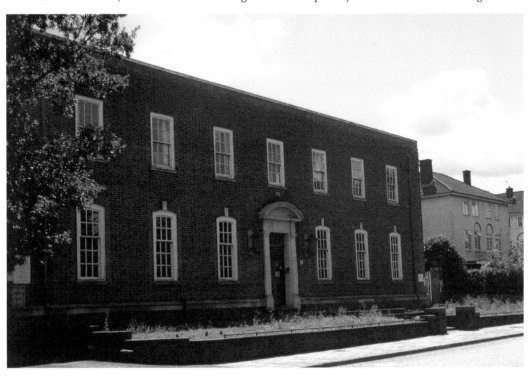

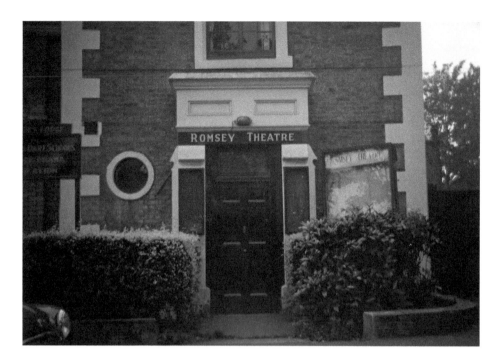

Romsey Theatre

Gladys Dare opened her School of Dancing at No. 7 South Terrace in the late 1940s. In 1965 she opened her Romsey Theatre at the same address, now No. 30 Ewell Road, presumably for her dancers to put on shows to the public. Plays would also have been staged here as it became the Gladys Dare School of Dance, Education and Drama. Since the Kingston Empire had closed in 1955, this small theatre was actually the only theatre in the district at this time. It closed in 1973 when the picture was taken, although Ms Dare continued to live here until 1977. Today the building is called Romsey Lodge and houses several flats.

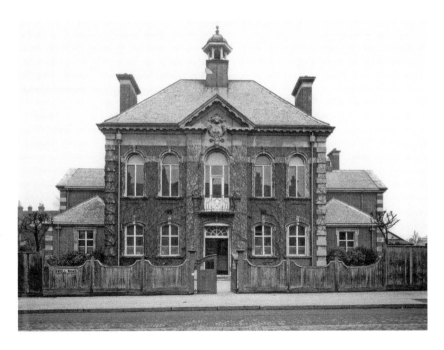

Sessions House

Surbiton fought off control from Kingston and established their own board of self-improvement with commissioners in 1855. These met in various places, including pubs and each other's houses until 1894 when Surbiton was made an Urban District Council. It was then decided that a proper council building was required and this magnificent building was erected in 1898 in the Ewell Road. Local government continued here until 1965 when Surbiton was amalgamated with Kingston. It then became a magistrates' courthouse for local 'sessions', hence today's name. The building was listed in 1984 and, despite an attempt to sell it off in 2012, is still borough owned. It is currently used as a learning disability centre.

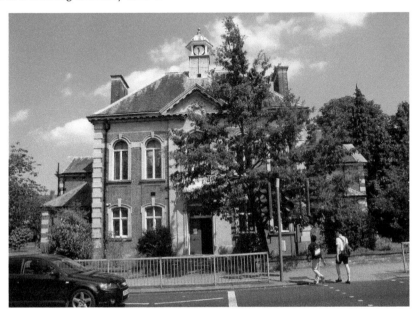

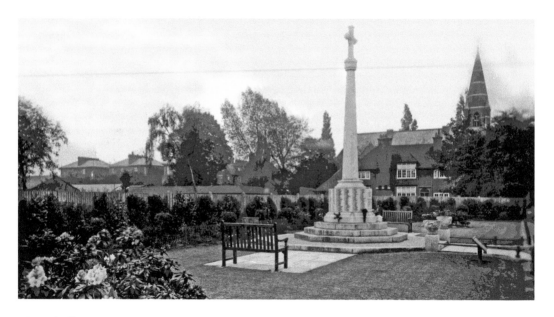

They Shall Not Grow Old

Surbiton War Memorial was unveiled in July 1921, paid for by public subscription. It has the names of 386 local men who were killed in the First World War, although the actual number may be higher since names had to be given in to the council and some families didn't do this or had moved away. One name not on the memorial because he happily survived the war is Douglas Belcher, who won the Victoria Cross in 1915. A centenary stone commemorating this was unveiled next to the war memorial in 2015. In the background is the Wesleyan Church, now Surbiton Hill Methodist Church.

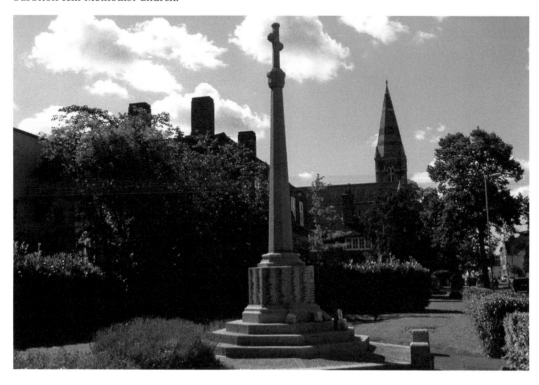

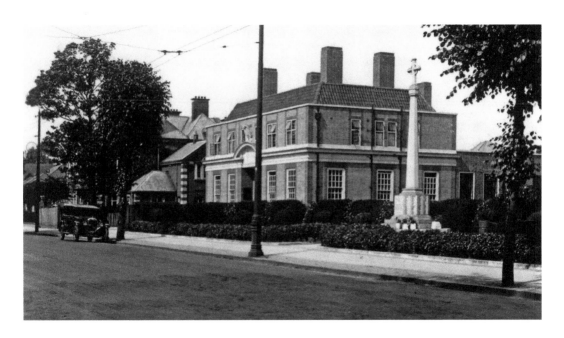

Surbiton Library

Surbiton had its own public library from 1929, and the foundation stone for this building in the Ewell Road was laid in 1931. It was officially opened in 1932 by Major Leycester-Penrhyn, the Chairman of Surrey County Council. Designed by Joseph Hill, it cost £21,820 with a further £1,900 spent on the initial book stock. Miss Roger was the first librarian and she told the *Surrey Comet* newspaper how keen she was to obtain a copy of the first history of Surbiton, written by Rowley Richardson in 1888. A library extension was built in 1964, followed by meeting halls.

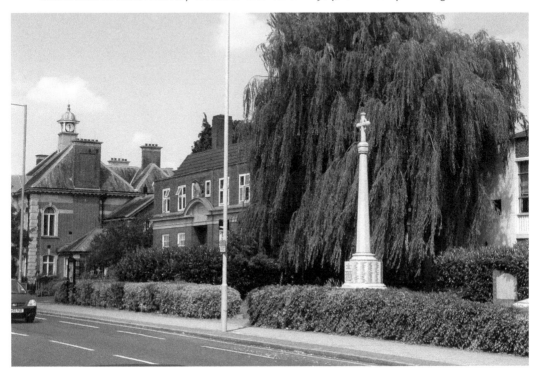

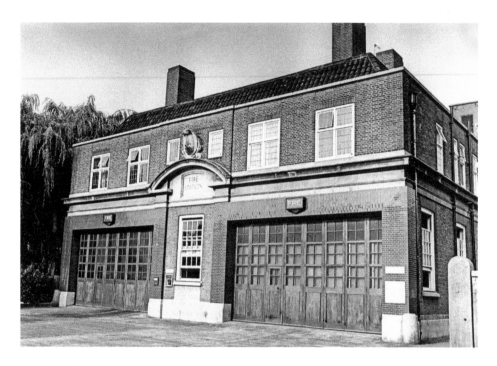

Surbiton Fire Station in 1975

Surbiton's volunteer fire brigade was founded in 1863 and they kept a fire engine in Fire Bell Alley off the Ewell Road. In 1879 they combined with Kingston and bought a new steam fire engine, which was kept in St James's Road and, after 1886, near Victoria Road. After the First World War, Kingston and Surbiton brigades separated again and Surbiton's new fire station was opened on the Ewell Road in 1932 at the same time as the public library. Both had been built by Gaze & Son to almost identical plans. The modern photograph shows little change except that an extra storey has been added to the tower behind. The poster is celebrating 150 years of the London Fire Brigade, which Surbiton station is now a part of.

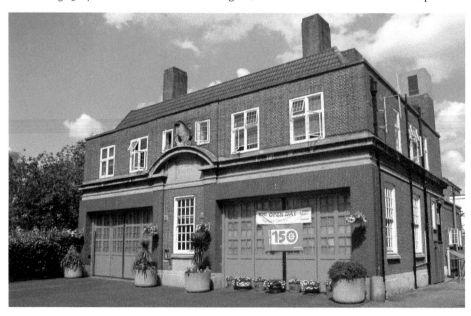

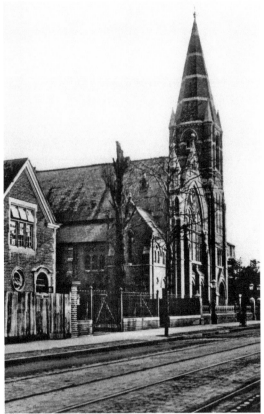

Surbiton Hill Wesleyan Church

Surbiton Hill Methodist Church (as it is now called) opened in 1882, replacing an iron church erected on the site in 1875. Wesleyan Methodists had been meeting in a private house in Alpha Road since 1858 before using Surbiton Hill Hall on the Ewell Road from 1861. Their iron church of 1875 was bought second hand from Wimbledon for £738, while the stone building of 1882 cost £5,660. The church is early Gothic in style and can seat 1,000 people. Space for a Sunday school was built into the rear of the church and extended in the 1920s.

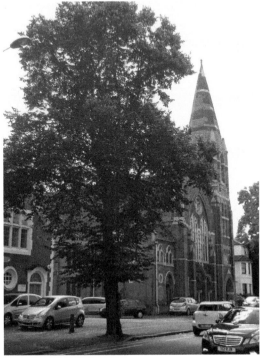

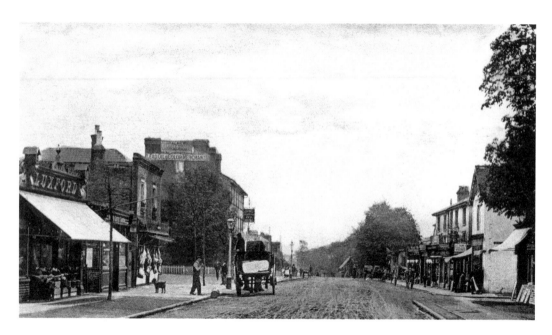

Ewell Road

This coloured postcard of around 1910 shows The Plough on the left at No. 107 Ewell Road, mostly hidden by the tree, just beyond Richmond Grove. The earliest date for The Plough is 1699 and it stood alone here for many years on the road between Ewell and Kingston before the suburb of Surbiton grew around it. It closed in 1994. In the foreground is Sydney Luxford's shop. He ran this fruiterer's at No. 97 Ewell Road from 1906 to 1926. He also ran stores at No. 16 Church Street and No. 4 The Broadway, Brighton Road. Next door to him is a coffee house and then a fishmonger's, although from the animal carcasses hanging up in front of the latter, it seems that the fishmonger also dealt in meat.

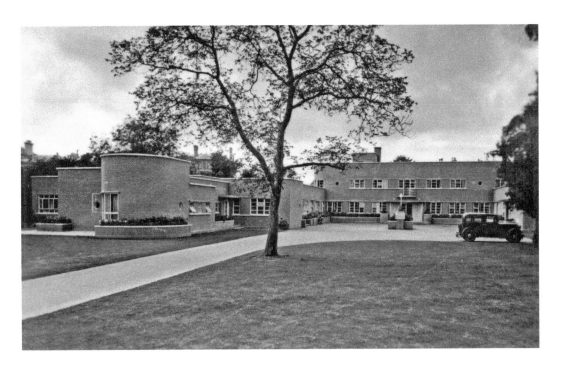

Surbiton Hospital

This hospital was opened as a replacement for the Cottage Hospital in 1936 on the Ewell Road. It had seventy-eight beds and cost £54,000. Further buildings were added in the 1940s and it became known as Surbiton General Hospital when it joined the NHS in 1948, although the 'General' was later dropped. The buildings became very dilapidated early this century and, rather than repair them, the hospital was closed in 2005 and the remaining patients were transferred to Tolworth. The premises were then demolished, with the exception of a small lodge house, and a new school, Lime Tree Primary, was built on part of the site. On the rest of the site, the new Surbiton Health Centre opened in 2012.

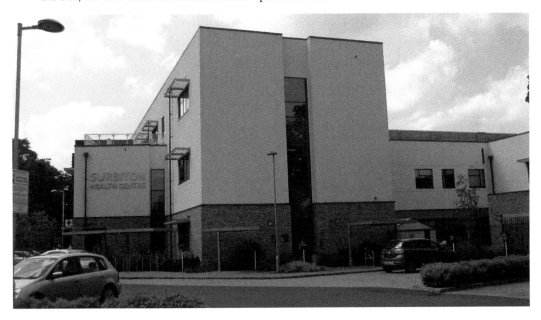

Brown's Brickyard

Brown's Road in Surbiton was named
after the nearby Brown's Brickyard. This
yard supplied the bricks for much of
the building in the Ewell Road area and
many of the houses in Brown's Road
built in the late nineteenth century
had wonderful brickwork to act as an
advertisement for him. Sadly, along
with many Victorian and Edwardian
houses in Kingston, these became
expensive to repair and unpopular to
live in and were frequently replaced by
'modern' flats and offices. This beautiful
house is being demolished in 1973
despite a last-minute bid by a Kingston
architecture student to get the houses
listed. Now Newent House occupies the
site. Formerly a care home, this now
houses adult education classes.

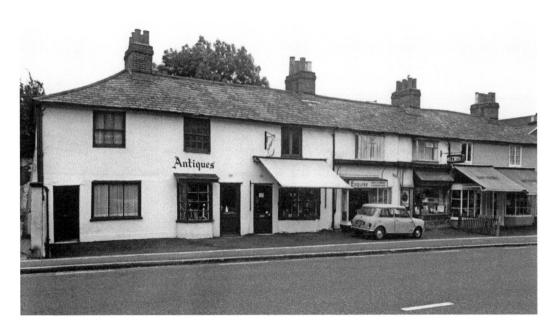

Nos 129–141 Ewell Road

The Antiques shop, shown here in 1975 and today, has been in operation since the 1920s when it was mainly a clock and watch repair shop under E. Sugg, who gradually added antiques to his repertoire. Esquire hairdressers opened as Pandora for ladies in 1957 but had changed to Esquire for men within a couple of years. Cynbeline Records also opened in 1957 but closed in the 1970s. Today, Esquire has become an Indian takeaway, Nawab, whereas Cynbeline is now Premier Cars, a car hire firm.

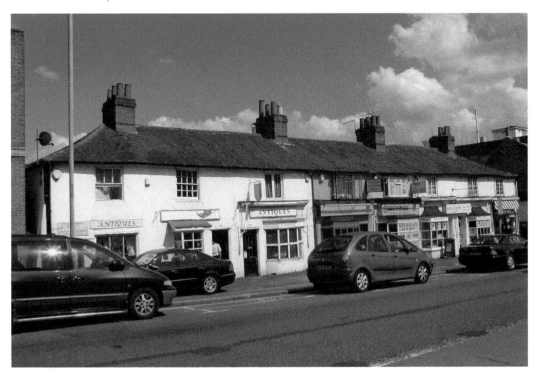

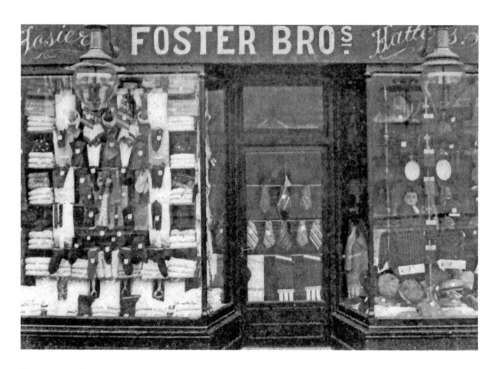

Foster Brothers

Foster brothers was a new shop at No. 114 Ewell Road when this photograph was taken in 1908. He is listed as a hatters in the street directories of the time but this shop display clearly shows shirts, ties and other clothes as well. In fact the sign at the top mentions hosiery as well as hats. Look carefully in the right-hand window. Is that a small child or a mannequin? Foster brothers failed to last beyond the First World War, closing in about 1920, although the shop continued as a drapers until the 1970s. More recently it was the Ajanta Indian restaurant. Sadly the shop is closed today, awaiting redevelopment.

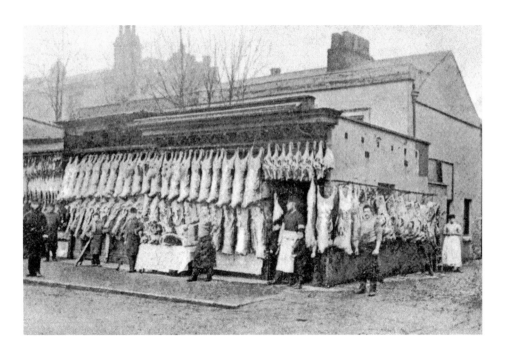

Mr Farmer the Butcher

William Farmer the butcher also had his shop at No. 126 Ewell Road, photographed in 1908, although he had been in business here since 1882, taking over from W. Hatch, another butcher. On show is a wonderful selection of meat and a large number of assistants. William was succeeded by his son, William Bance Farmer, who continued until the Second World War. Mr Butlin then ran the premises, also as a butcher's shop, until 1966 when it became a car hire outlet. It is still one today: Concept Vehicle Leasing, with a much larger building now incorporating flats above.

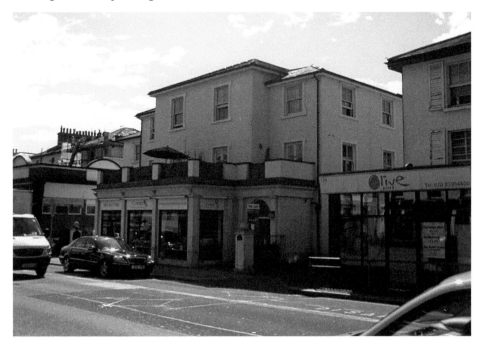

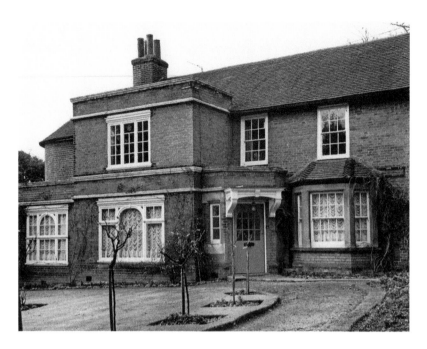

Fishponds House

Fishponds House is named after the seven 'fishponds' that used to be in the grounds. There is some evidence of a pond in the area in medieval times, but it was not necessarily here, and there is much more compelling evidence that these ponds were the result of clay extraction in the eighteenth century. Only one pond survives today in the small park. The house and grounds belonged to the Butler family, who made their fortune from Lambert & Butler cigarettes. In 1935 they sold it for £10,000 to Surbiton Urban District Council, who used it as council accommodation and a small public park. It is very hard to photograph the house today because of a cluster of garages and lots of trees and bushes.

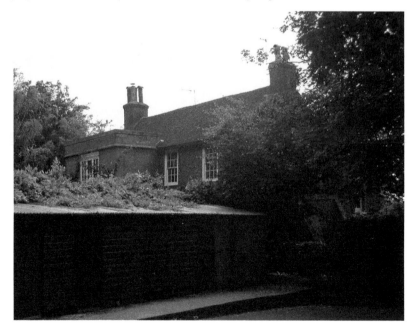

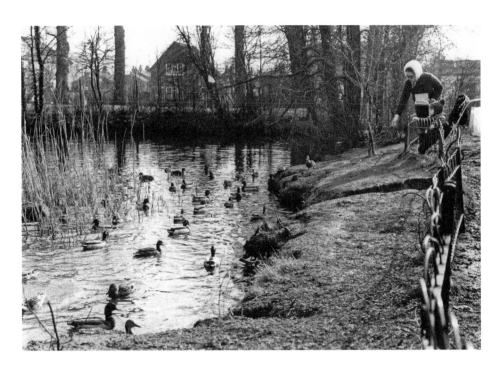

The Fishpond

When clay extraction finished, most of the ponds were filled in but this one remains just in front of Fishponds House. The small fence visible in the 1973 photograph has been taken away so it is much easier to feed the ducks. Unfortunately, the council has not tidied up here for a while and the pond was full of green algae when I took the modern photo. The ducks didn't seem to mind and there are also coots, moorhens and Canada geese there today – a pleasing oasis on the Ewell Road near Tolworth.

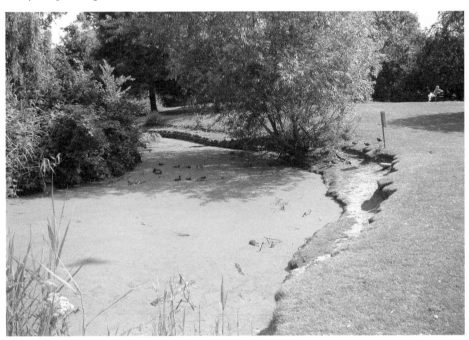

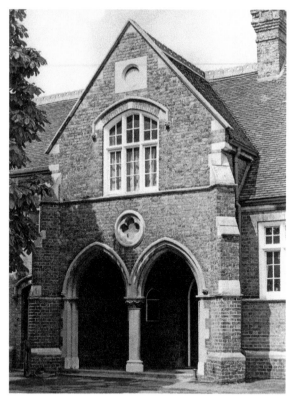

The First St Matthew's School

St Matthew's Church Day Schools were built in 1879 and accepted their first children in 1881. An extension was built in 1901. In 1910, the older children were moved to the new Tolworth Junior School between Douglas Road and Red Lion Road. St Matthew's still exists as an infant school but is now in Langley Road. This building was used as Surbiton Police Station from 1974 (the date of the old photograph) for nearly twenty years. In 2011, the building was bought by the London International Study Centre, which prepares overseas students for British universities. It was recently renamed London Tutorial College.

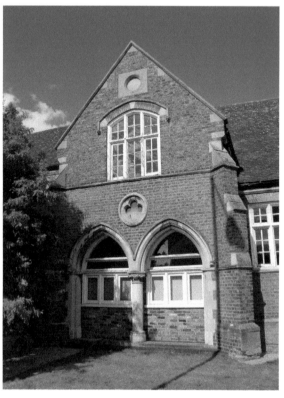

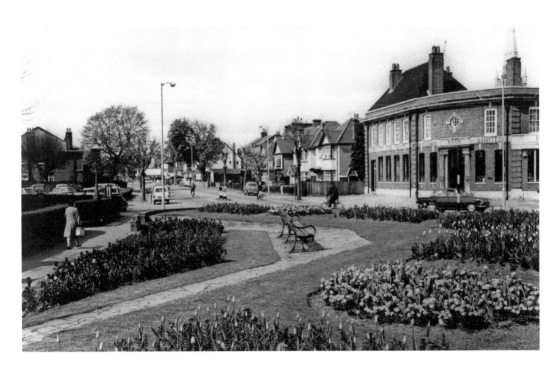

Ditton Road

The impressive bank building in this photograph is Barclays Bank at No. 2 Ditton Road, by the junctions with Ellerton and Ewell Roads. Pictured in 1950, it seems to have been closed in the 1970s when it was replaced by Europa Ski Lodge at a time when British people were first starting to go on skiing holidays in large numbers. The roads have become much busier since, and the quiet little garden has halved in size to accommodate a larger junction. A large new block of flats is being constructed on the left in Ellerton Road.

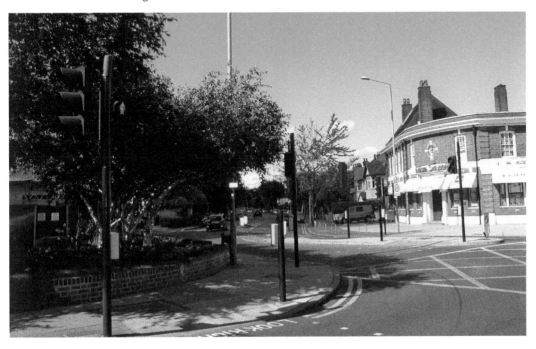

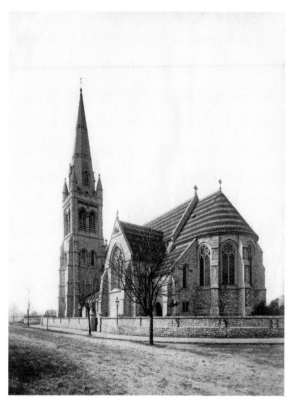

St Matthew's Church

St Matthew's parish church, just off the Ewell Road in St Matthew's Avenue, was opened in 1875 to serve the growth of the population in the south of Surbiton on the borders of Tolworth. The parish of St Matthew's was formed from part of Christ Church's parish but mostly from Tolworth, which had previously belonged to the parish of Long Ditton. The land was donated by Robert Curling, who bought it from the Southborough Estate. The church and vicarage cost £24,000, which was all paid for by William Coulthurst, a partner in Coutts Bank, which owned much of Surbiton after the bankruptcy of Thomas Pooley.

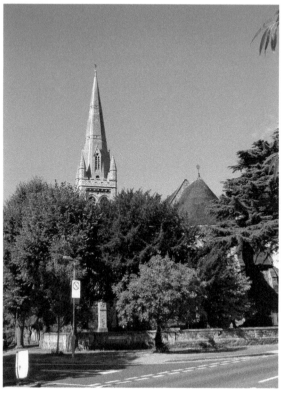

Police Station

Surbiton first asked for a police station in 1867, the year that Kingston's station opened. They envisaged a small cottage with one constable. The idea was postponed until 1884 when the population had increased, and then postponed again because locals objected to the planned site in Langley Road. Surbiton Police Station finally opened in Ditton Road in 1888 and is shown here in 1972 just before it closed. The police station then moved nearby to the old St Matthew's School building. Today the original Ditton Road building has been demolished, and a new apartment block is being built.

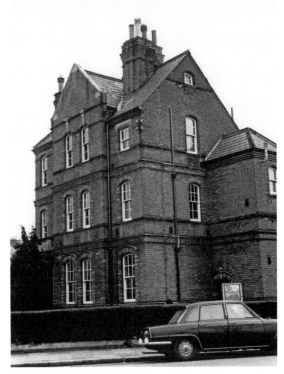

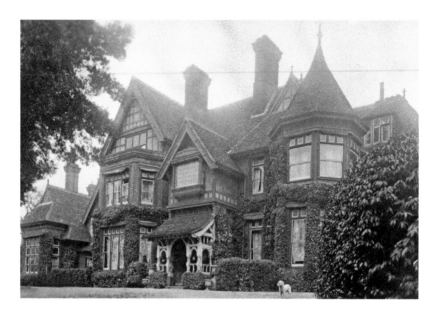

The Gables

This house was built by Wilberforce Bryant of the match company, Bryant & May, in 1877 to be his country house. In the grounds, he built a theatre in 1884 for the use of the local community. This theatre was known as The Gables and this name later transferred to become the name of the house, previously simply known as 'Mr Bryant's House'. When Surbiton became more populous and busy, Mr Bryant moved out to Stoke Park near Guildford, and the house was bought by Alfred Cooper in 1888. The latter founded Genesta Amateur Dramatic Society and used the theatre for shows. During the Boer War, Cooper converted the theatre into a hospital to treat returning soldiers who had been wounded and for this he was knighted. The final private owner was Herbert Boret. He lived there from 1906 to 1926, when it became Hillcroft College.

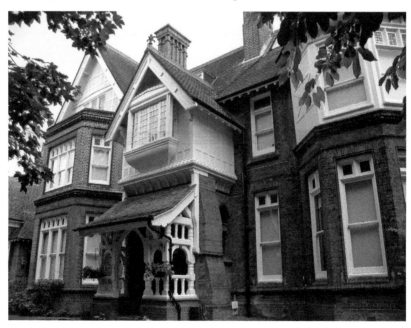

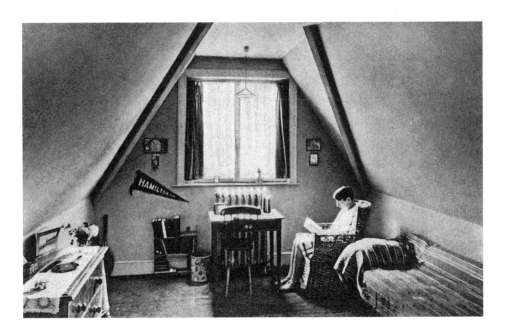

Hillcroft College

In the 1920s, the idea of a college for working women was being discussed when The Gables came up for sale at an opportune moment. It was purchased with the help of William Wall (of sausage fame) for £10,000. The idea was (and is) to provide residential education for mature women. Grants are provided and women can qualify for a Certificate of Higher Education, which can help them pursue a wide variety of degrees and other courses that might otherwise be closed to them. A student room set in one of the gables of the house is shown here. Although students still live in, this particular room is now an archive store. Hillcroft College received a 'name check' on ITV's *Downton Abbey* when Lady Edith joined the board!

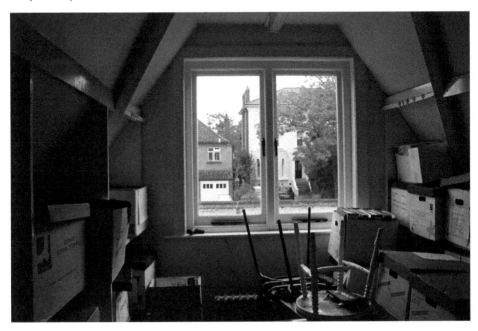

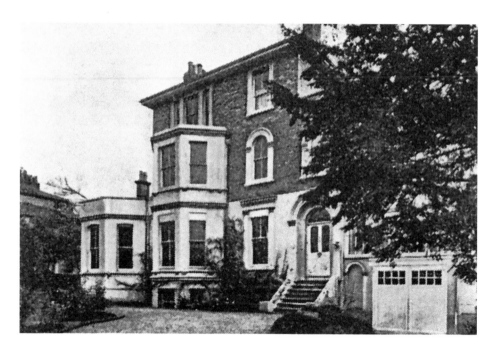

From Hazel to Ash

Hazelwood School seems to have been a one-woman project, the brainchild of Miss Evelyn Mudie. Her school for girls was opened at No. 14 South Bank in around 1936 and closed in around 1955; Miss Mudie was the headmistress throughout. The old photograph is one of a series of postcards of the school produced in 1951, presumably as an advertising campaign to encourage more pupils. Today there are no houses at all in South Bank; they have all been replaced with apartment blocks. The name Hazelwood survives in Hazelwood Close, just off South Bank to the left of Ashby House in the modern photograph.

National Carriers Depot

Carter Patterson (carriers) had a depot here in Glenbuck Road (but on the other side) from 1936. They moved to this side of the road (Upper Brighton Road side) in 1940 and continued here until 1958. They were then replaced by British Road Services (Parcels) from 1959 to 1971 before they were taken over by National Carriers. Today the site has some terraced houses at the far end, but it has mostly been replaced by Saxon Court, a series of apartment blocks off Glenbuck Road and Saxon Close.

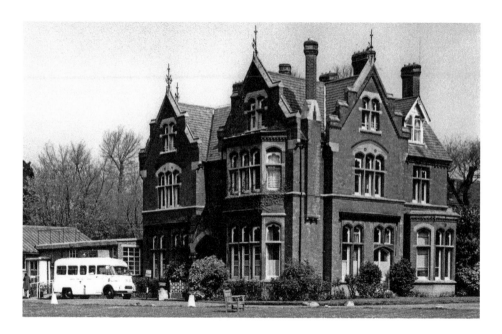

The Royal Eye Hospital

The Royal Eye Hospital was originally based in Southwark but was badly damaged by bombing in 1941. Southborough Villa in the Upper Brighton Road in Surbiton was chosen as a temporary replacement but it became a permanent hospital after the war with the founding of the NHS. In 1948 it was known as the Surbiton Branch of the Southwark Royal Eye Hospital. This was shortened to the Royal Eye Hospital when it came under the control of the Kingston and Richmond Area Health Authority in 1973. In 1981, four years after this photograph was taken, it moved out to Kingston, and Southborough Villa was demolished about ten years later. It is now covered by the flats of Penners Gardens, although the original lodge survives.

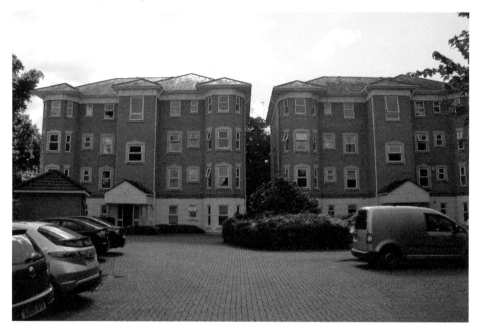

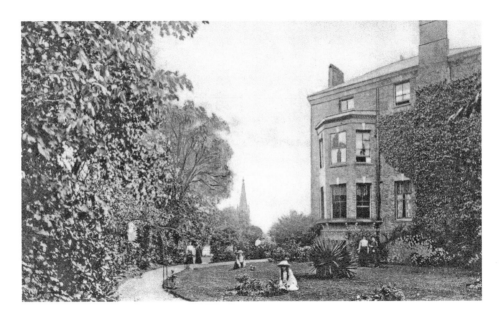

St Bernard's

St Bernard's was built in 1873 on the Brighton Road (now No. 19 Upper Brighton Road) and by 1895 it was being used for a school run by the Misses Miller. It was taken over around this time by Miss Pakenham-Webb and Mlle Davies and was a school for young ladies called St Bernard's School. In around 1903 it became known as the Anglo-French School. This continued until 1911 when the staff was Miss Suttell and Mlle Bosseux. In 1913, a new St Bernard's School for Girls opened and this continued until the 1940s. After the war it became a medical examination centre and recruiting offices for HM Armed Forces, as well as a local tax office. Now it is a private house that has lost a lot of the original side garden to make way for a roundabout.

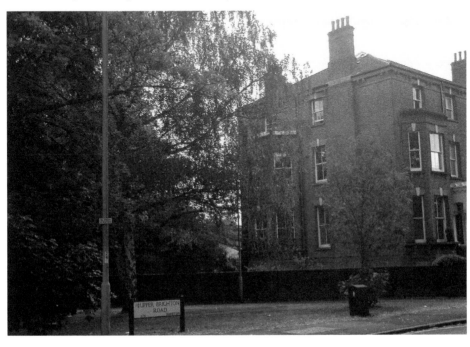

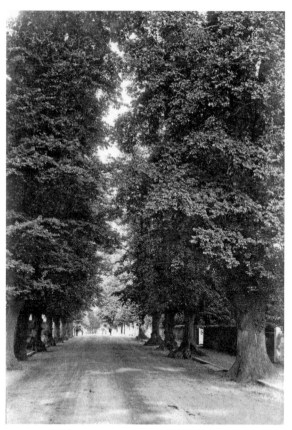

Langley Avenue

Southborough Farm grew into an estate covering 200 acres by 1851. The early nineteenth-century owners were Sarah and Thomas Langley and the wooded road on which the estate lay became known as Langley Avenue. In 1864, Mr Curling sold off the land for development but the great trees lining the road then were still in place when the early photograph was taken in *c.* 1900. The road has not changed much today, although the trees have been thinned out. The big houses are often flatted or turned into care homes, but they retain large drives, meaning there are not too many cars parked on the road.

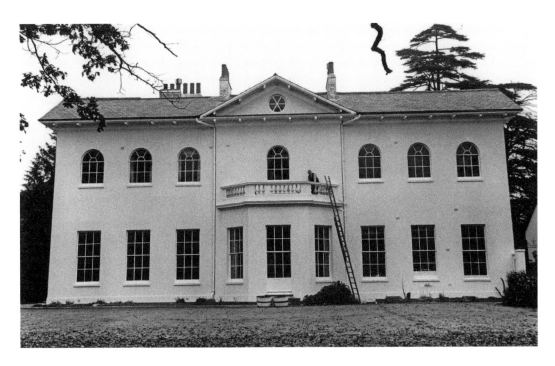

Southborough Lodge

Southborough Lodge in Ashcombe Avenue was built in 1808 and is thought to have been designed by Thomas Nash. Thomas Langley was the owner in 1838, when he donated land for the building of St Paul's Church, Hook. In 1855, the owner was Charles Corkran who supported the Surbiton Bill to set up Surbiton's commissioners, their first local government, separate from Kingston. In the 1970s, the house was split into two properties and the coach house became a private house as well.

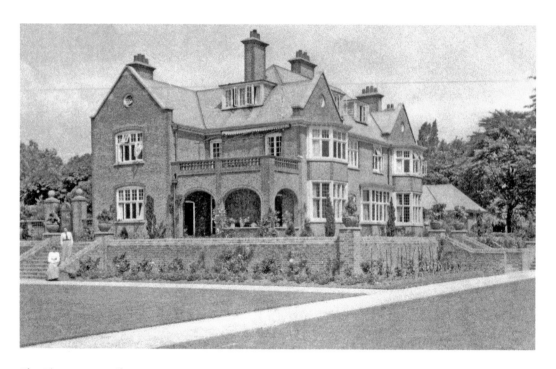

The Zimmern Family

Oakhill Dene in Oakhill Drive was the home of the Zimmern family from before 1879 when Alfred, son of Adolf (originally from Germany), was born. He went on to help found the League of Nations and UNESCO, and first coined the phrases British Commonwealth and 'welfare state'. His elder sister, Elsie, born in 1876, attended Surbiton High School and went on to promote the rights of working women. She then became a lynchpin of Associated Country Women of the World, and there is a memorial fund in her name providing scholarships in social welfare. The house was demolished in the 1960s and the site is now in the playing field behind the present St Matthew's Primary School.

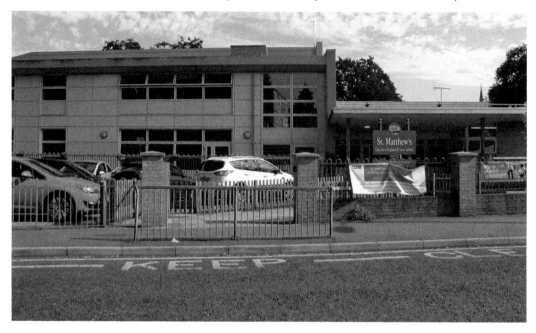

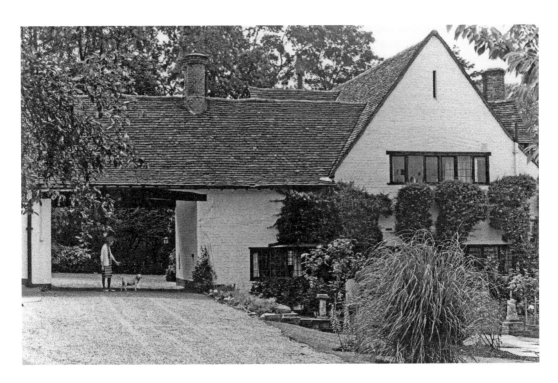

April Cottage

April Cottage is not an original Surbiton building. It originally graced a busy street in Enfield where it was an inn, allegedly frequented by Dick Turpin. It was threatened with demolition in 1927 and so, to save it from this fate, Henry Gaze bought it and moved it brick by brick to Surbiton. He was perhaps connected to the well-known firm of Kingston builders called Gaze & Sons. At the rear of the house in Woodlands Road is Cock Crow Hill and the house was originally known as Cock Crow Close before the name was changed to April Cottage some time before the old photograph was taken in 1974.

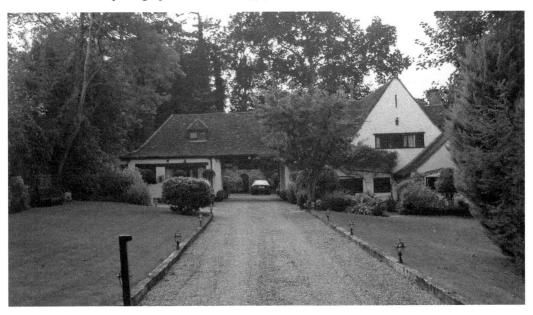

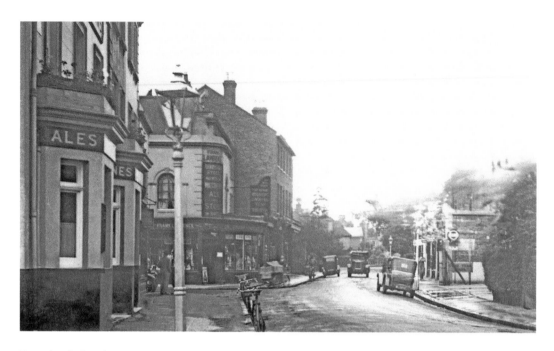

Berrylands Road

The 1930 photograph shows Berrylands Stores at the centre left, which were run by Frank Lawrence at this time. They were eventually incorporated into The Bun Shop next door. Nearer to us on the left is The Paragon Arms, a pub since before the 1850s. This closed in 1961. It then became a car dealership for Skoda and Kia, but is now a Londis supermarket. Across the road, Good Year Tyres are being advertised at a garage, which has now been replaced by Fulmar Court flats on Fulmar Close.

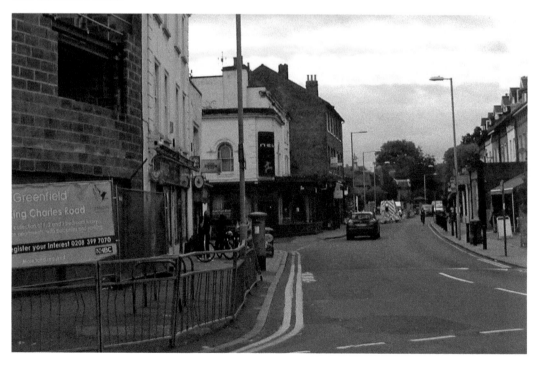

R. H. Oakey and The Bun Shop

R. H. Oakey, on the corner of Berrylands Road and Paragon Road in the photograph of 1973, ran his off-licence from 1953 to around 1975. His premises was next door to The Bun Shop. This unusual pub was a bakers and confectioners, which was given a licence in 1890 because the Surrey Board of Guardians used to meet there, but the rule was that it had to close at 9.30 p.m. and that rule lasted until the 1950s. It then became a proper pub with a full licence but still sold buns and cakes in the 1960s. Oakey's former premises became part of the pub in 1985. Today it is Brave New World, a pub featuring live music and comedy nights.

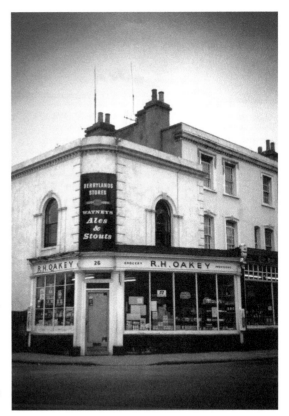

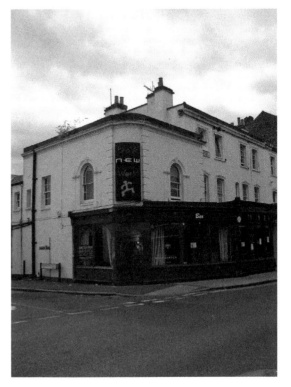

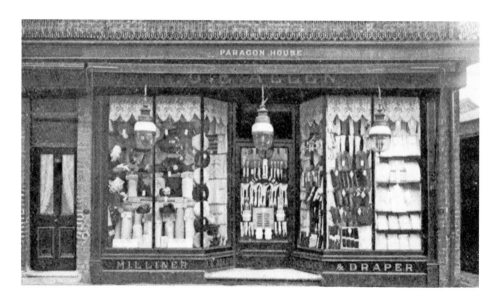

Paragon House

John Allen, fancy milliner and draper, ran his 'Paragon House' shop at No. 16 Berrylands Road from 1895. He presumably named his shop after the nearby Paragon Arms public house. Today the shop is a remarkable survival and identical to the shop in 1908, even to the iron balustrade above, which has survived the Second World War when so many iron railings were removed for the war effort. This stability is no doubt due to the fact that the shop remained a drapers under various owners until the 1970s at least, although the last occupier who has just closed was a domestic appliance repairer. Sadly, the shop is currently empty so let us hope it meets with a sympathetic new owner who preserves this historical gem.

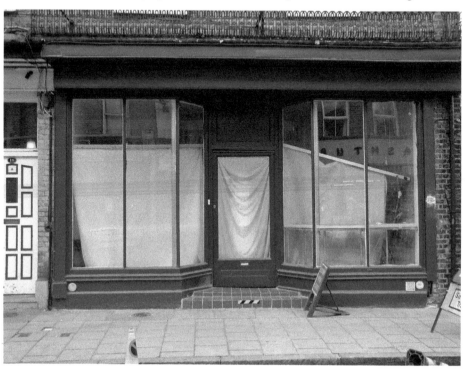

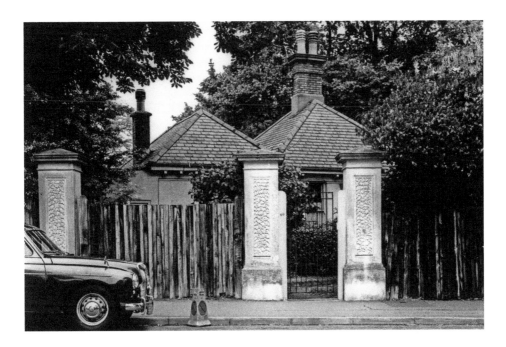

Regent House

Regent House was built in the 1870s, replacing Berrylands Farm, by Daniel and Celestine Nichols, who ran the famous Café Royal in Regent Street. Daniel's son-in-law, George Pigache, chose the wines for the cellar but clearly also enjoyed the food and weighed a vast 36 stone. He could not fit into a horse and carriage but had to go to Surbiton Station on a farm cart. Three porters then had to manoeuvre him into the train. Daniel died in 1897 and George in 1898. Celestine survived until 1916 but the estate was then sold off for housing in Regent Road. Regent Cottage shown here was the original lodge house, replaced in the 1970s by The Lodge at No. 9 Berrylands.

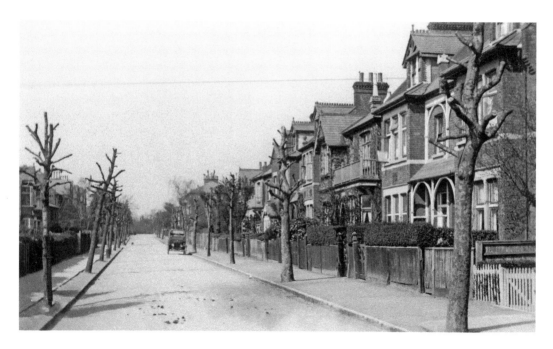

King Charles Road

An even earlier photograph of King Charles Road shows a single small house surrounded by fields, but in this photo of *c.* 1910, the road has been fully developed with Victorian semi-detached houses. These were replaced by the apartment blocks in the 1980s. The number of cars in the road has also grown considerably. The road is named after Charles I because it was in this general area that the Battle of Surbiton was fought in 1648. The Royalists were attempting to restore Charles to the throne but succeeded merely in precipitating his execution the following year.

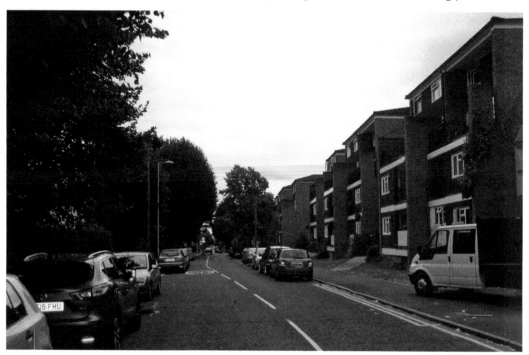

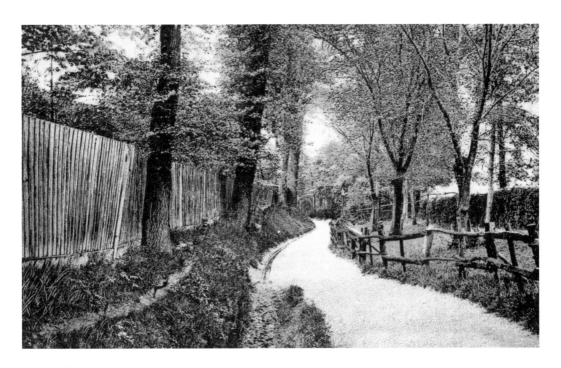

Villiers Path

Villiers Path is a footpath that runs from Lambert Road near the junction with King Charles Road through to Surbiton Hill Road near Avenue Elmers, all along the back of Hollyfield School. The name is another commemoration of the Battle of Surbiton because it is named after Lord Francis Villiers. He was the younger brother of George, Duke of Buckingham, and they both fought here for the Royalists. Francis Villiers was killed with his back to a great elm tree in the late afternoon on 7 July 1648. The elm tree (carved with a 'V') survived until 1680. The path has become rather dark and more overgrown since Edwardian times.

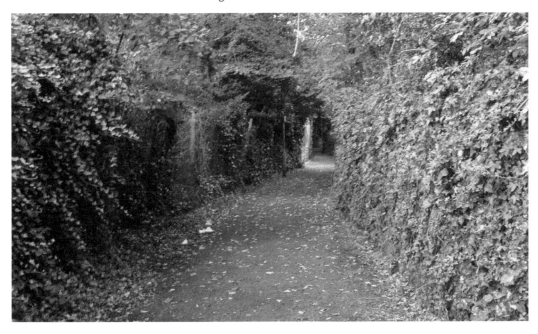

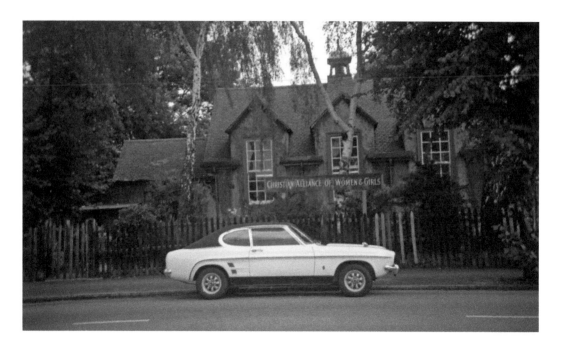

Christian Alliance

The Christian Alliance of Women and Girls was listed at No. 41 King Charles Road from 1935 to the 1970s when the photograph was taken. Sharing the site between 1955 and 1966 was St David's Nursery School. The Christian Alliance, as it was renamed in 1968, was founded in 1920 to support vulnerable working women by opening hostels for them to stay in. The attached nursery school in this Surbiton branch would have been a useful adjunct. Some branches have gone on to become housing associations, while Scottish branches merged with the YWCA. This building is now the Berrylands Christian Centre and is also rented out to the Rivers of Water Church, part of the Redeemed Christian Church of God.

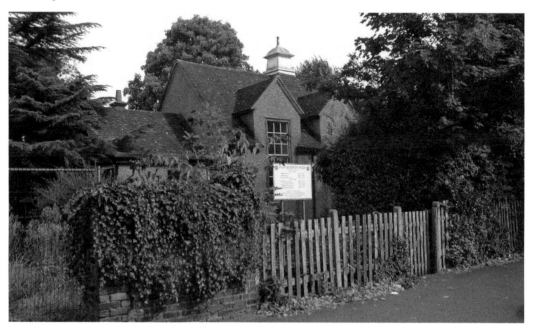

The Manor House, Surbiton

The Manor House originally belonged to Alexander Raphael, who built St Raphael's Church. After his death, sometime in the 1850s, The Manor House became a convent and school. This is a Marian shrine in the garden in *c.* 1900. The shrine also had a statue of the Child of Prague (the infant Jesus in crown and robes). The Manor House was demolished in 1911, but the school continued at Nos 9–13 The Avenue until the 1950s. Now it is the site of Adams Close, where visions of Our Lady of Surbiton have been reported from the 1980s. There is a poster in the vicinity about the sanctity of unborn children and a crucifix up in the trees but I have been unable to discover if prayer meetings are still held.

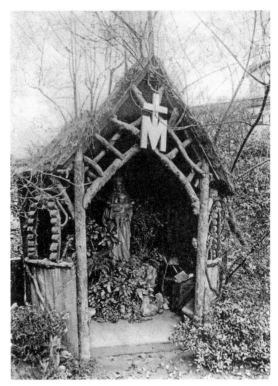

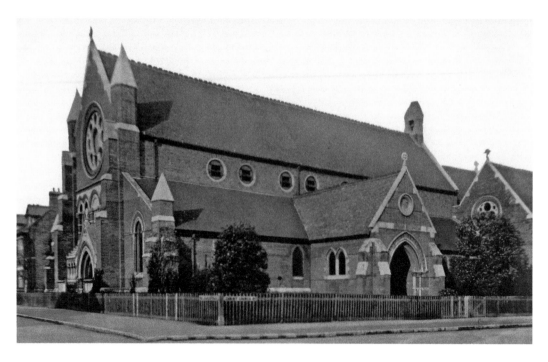

Christ Church, Surbiton

Christ Church was planned and built by evangelical worshippers in the Surbiton Hill area who did not like the services at St Mark's and were tired of travelling to St Paul's, Hook, to get an evangelical service. It was built on the corner of King Charles Road and what is now called Christchurch Road, Berrylands. A brick church in early English style, it was opened in 1863. The parish of Christ Church was formed out of St Mark's. The total cost was £4,000, plus £1,400 for a vicarage. The church was enlarged in 1864, 1866 and 1871, such were the demands of the increasing population. It is still a flourishing evangelical church today.

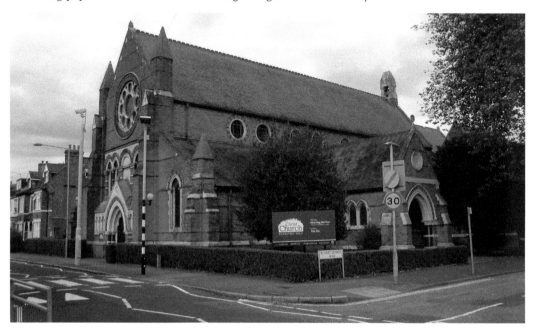

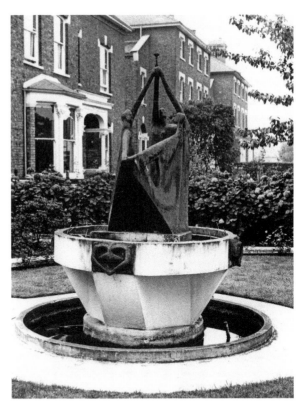

Artistic Surbiton

This modern artwork is in the front
garden of No. 6 Christchurch Road.
It is by the artist David Tompkins,
about whom I have been unable
to discover anything further. It
was built for Alderman Healy in
1973 and is a fountain as well as a
sculpture. Alderman Healy's father
developed an early form of pilotless
aircraft during the First World War
but the RAF showed a distinct lack
of interest and it was left to the
Americans to succeed with the idea.
Alderman Healy was himself an
industrial chemist and prominent
in Kingston Council, where he
represented a Surbiton ward.
Aldermen were councillors chosen by
other councillors for their experience,
rather than being elected. There were
ten of them but they were dropped
in 1978.

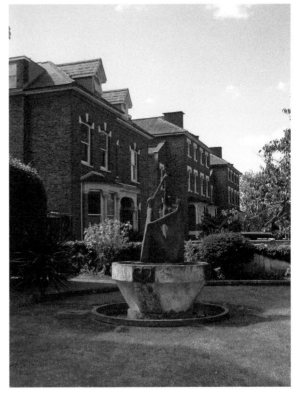

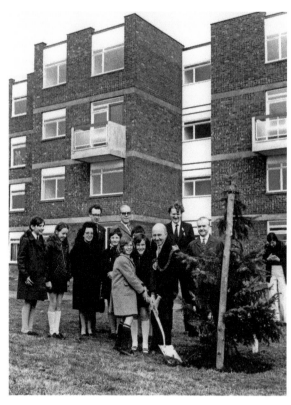

Plant a Tree in '73

Alpha Road was previously known as Middle Green Lane and was in a very poor state when the Surbiton Improvement Commissioners came into being in 1855. It was the first road they improved with proper drainage and surfacing and so they renamed it Alpha Road. Another idea of those early commissioners was to plant lots of trees to improve the neighbourhood, mostly lime trees. Over 100 years later we see Alderman Healey planting a tree at Hobill Walk on the new Alpha Road Estate, which had replaced the old Victorian terraces. The tree planting of 1973 was a nationwide scheme to beautify our towns and suburbs.

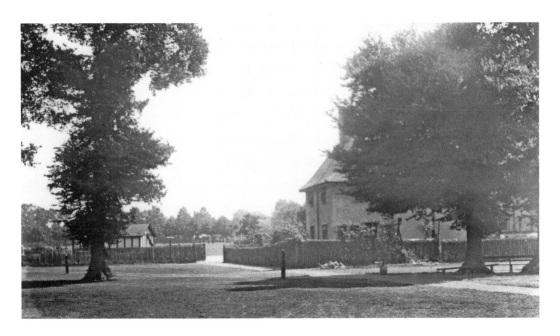

Alexandra Recreation Ground

This 16.5-acre area of land was purchased to be used as a recreation ground just before the First World War, thanks principally to the efforts of Councillor Dumper. It was named after Edward VII's wife, Queen Alexandra. Parts were also set aside for allotments, and the Surbiton Lagoon was built here in 1934. Religious services were held here for the 1937 coronation and for VE Day in 1945, when a miniature railway was set up for rides. Air-raid shelters had been built here during the war. Today it is a great sporting arena where you can play football, tennis, basketball, bowling, croquet and cricket. There is also a playground for little ones and a public toilet. The house in the foreground is now an office for Kingston parks, with all their vehicles and other equipment behind the fenced-off area.

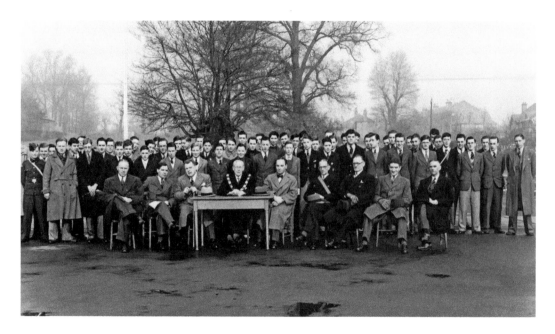

ATC Enrolment, 1941

This is a better view of the park showing its great expanse. In 1941, Britain stood alone against the might of Nazi Germany after the French had surrendered and before the Americans entered the war. This was also the time when the Soviet Union was still an ally of Hitler. Air power was the main means Britain had to fight back, and the Air Training Corps had a recruitment drive in the War Weapons Week of 1941. Boys aged 16–18 were encouraged to join for training and eventual service in the RAF. Eustace Ames was the Surbiton mayor and four 'flights' of fifty boys each were enrolled. Many of these boys would serve in Bomber Command later in the war. They signed on at the council offices but the photograph looks like it was taken on Alexandria Recreation Ground.

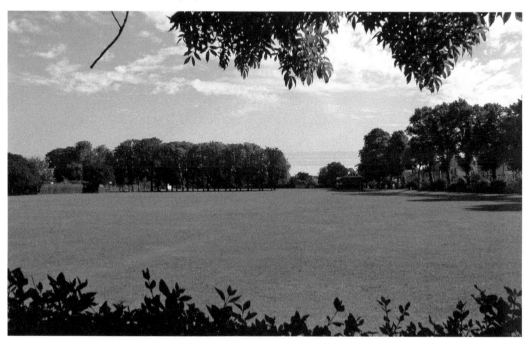

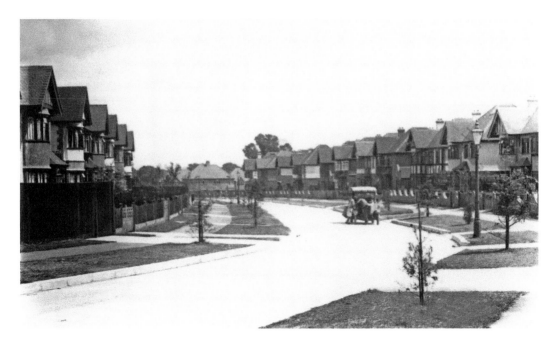

Pine Walk

Much like its neighbouring boroughs, Surbiton expanded greatly during the 1920s and 1930s. Most of its remaining fields were built on to provide housing for people moving out of crowded London into properties with more space and fresher air. Pine Walk was laid out in 1929. All these new people needed schools and other facilities and this was part of the reason Surbiton became a borough (as opposed to an Urban District Council) in 1936, to give councillors more powers. There are a few more cars in today's view but the main difference is in the trees and shrubs, which have grown tremendously.

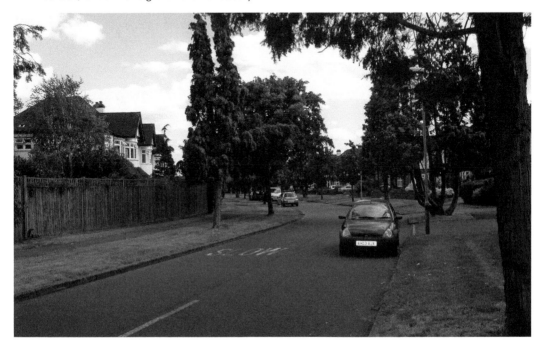

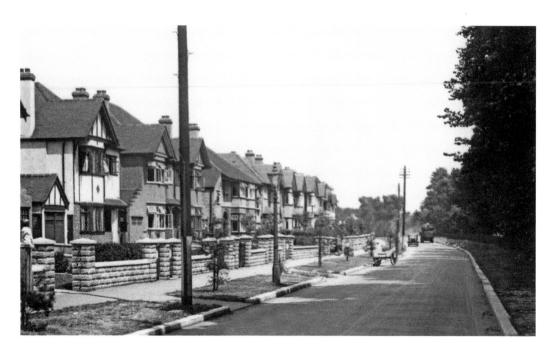

Alexandra Drive

Alexandra Drive was also laid out in the 1920s. On the right of the photo is Alexandra Recreation Ground, from which Alexandra Drive took its name. Rush hour in the 1930s consisted of a car and a lorry plus a parked old-fashioned hand cart, probably making local grocery deliveries – the Ocado of its day. Today, cars are parked all along the north side despite most of the houses having drives and, like Pine Walk, there is a lot more mature greenery.

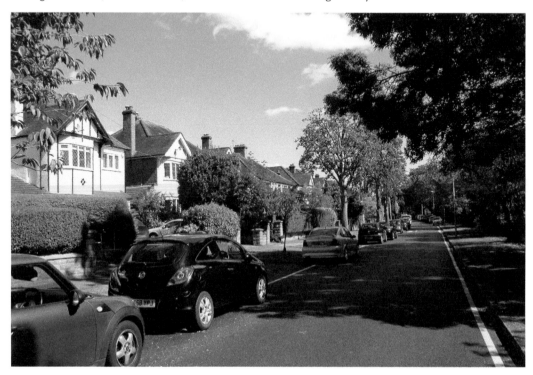

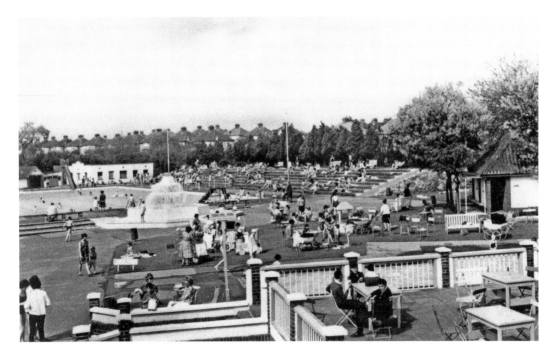

Surbiton Lagoon

Surbiton Lagoon was a large open-air swimming pool opened by the council in 1934. The 'Blue Lagoon' was originally considered as a name but the council worried that users who had read the book of that name might be expecting 'something in the way of a return to nature'. During the war there was a large air-raid shelter here, built for seventy, but often coping with twice that number. The pool opened every summer until 1979, when the council became concerned about ongoing maintenance costs and it never opened again. Part of the site was redeveloped for housing in Meldone Way, but the pool was simply filled in and the site grassed over.

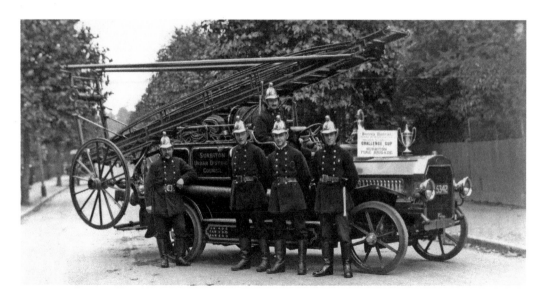

Surbiton Fire Engine
Members of Surbiton Urban District Fire Brigade stand proudly by one of their new motor engines in 1930. These had replaced steam-powered models just a few years before. The notice on the bonnet reads: 'Surrey District, National Fire Brigade, President & Committee Challenge Cup presented to Surbiton Urban District Fire Brigade' and the cup can also be seen next to the notice. Unfortunately, the author has been unable to find out what the cup was given for.

Acknowledgements

First and foremost, thanks go to Kingston History Centre and their Local History Officer, Amy Graham, who helped with the vast majority of early photographs. Some of these are also copyright of *Surrey Comet*, who took over the old Kingston Borough News Archive and I am grateful, as always, to June Sampson for allowing the use of these.

Other old photos were provided by my wife Shaan Everson (Butters) (pp. 11, 26, 35, 37, 39, 46, 48, 55, 57, 71, 75, 88) and my sister-in-law, Amanda Tree (pp. 6-7, 10, 14, 40–41, 47, 59, 95). Thanks for help with modern photos go to Sandy Philpotts for the Hillcroft College interior, Rowan Verity for the Assembly Rooms interior and Revd Robert Stanier for his portrait.

Books consulted include my wife's magnificent *That Famous Place: A History of Kingston-upon-Thames*; Rowley Richardson's *Surbiton: Thirty Two Years of Local Self-Government 1855-1887*; Richard Statham's *Surbiton Past*; Richard Holmes' *Pubs, Inns and Taverns of Surbiton and Malden*; Mark Davison & Paul Adams' *Surbiton Bombed* and Patricia Ward's (with Bob Phillips) *The Story of Tolworth*. Also the many books and articles in the *Surrey Comet*, by June Sampson and those in the *Kingston Borough News* by Margaret Bellars.

Finally, my wife's collection of church notes has also proved invaluable. Other research was carried out at the Kingston History Centre's collection of maps and directories. I am most grateful to my wife Shaan for her expert proofreading and advice!